TREES UP CLOSE

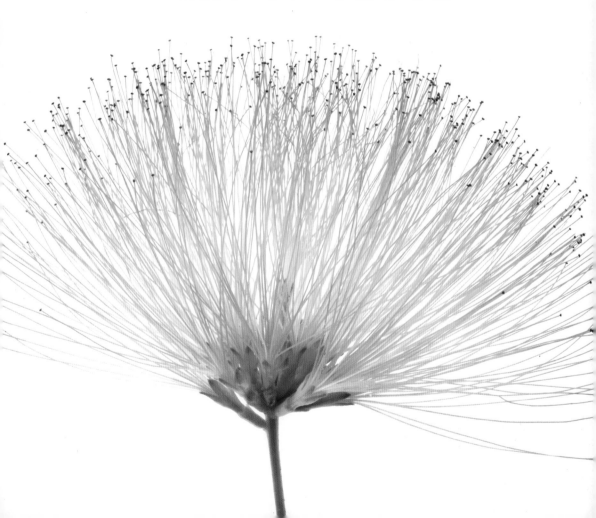

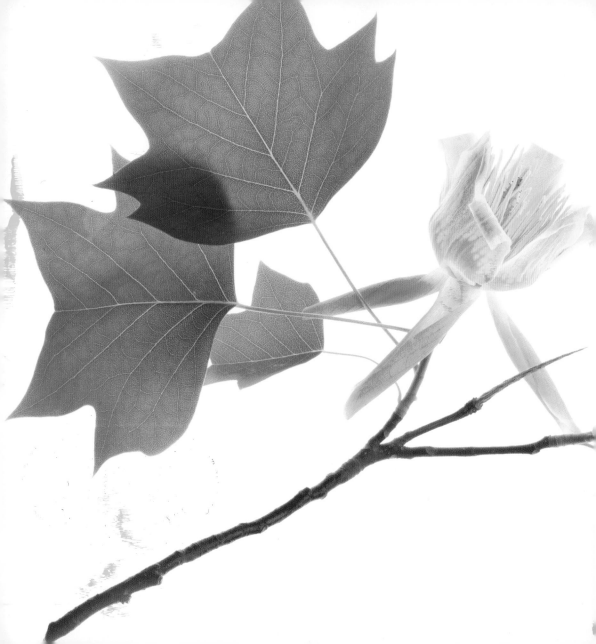

TREES UP CLOSE

The beauty of bark, leaves, flowers, and seeds

NANCY ROSS HUGO
photographs by **ROBERT LLEWELLYN**

TIMBER PRESS Portland, Oregon

Page 1: Thread-like stamens and styles create the familiar pom-pom of mimosa, *Albizia julibrissin*.

Frontispiece: Tulip poplar (*Liriodendron tulipifera*) leaves have a characteristic depression at top, giving them a saddle shape.

Opposite: Emerging American beech (*Fagus grandifolia*) leaves stretch free of their golden bud scales.

Published in 2014 by Timber Press, Inc.

The Haseltine Building
133 S.W. Second Avenue
Suite 450
Portland, Oregon 97204
timberpress.com

Printed in China
Second printing 2016
Text and cover design by Susan Applegate

Library of Congress Cataloging-in-Publication Data

Hugo, Nancy R.
 Trees up close: the beauty of bark, leaves, flowers, and seeds/Nancy Ross Hugo; photography by Robert Llewellyn.—First edition.
 pages cm
 Other title: Beauty of bark, leaves, flowers, and seeds
 ISBN 978-1-60469-582-3
 1. Trees—Pictorial works. I. Llewellyn, Robert J. II. Title. III. Title: Beauty of bark, leaves, flowers, and seeds.
 QK475.6.H84 2014
 582.16—dc23 2014010187

catalog record for this book is also available om the British Library.

"Thinking is more interesting than knowing,
but not so interesting as looking."

JOHANN WOLFGANG VON GOETHE

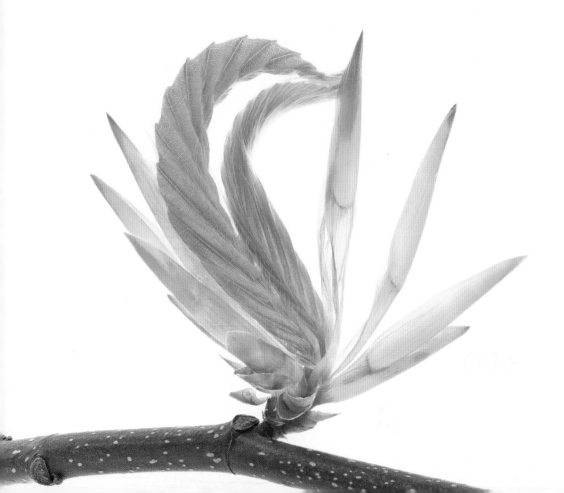

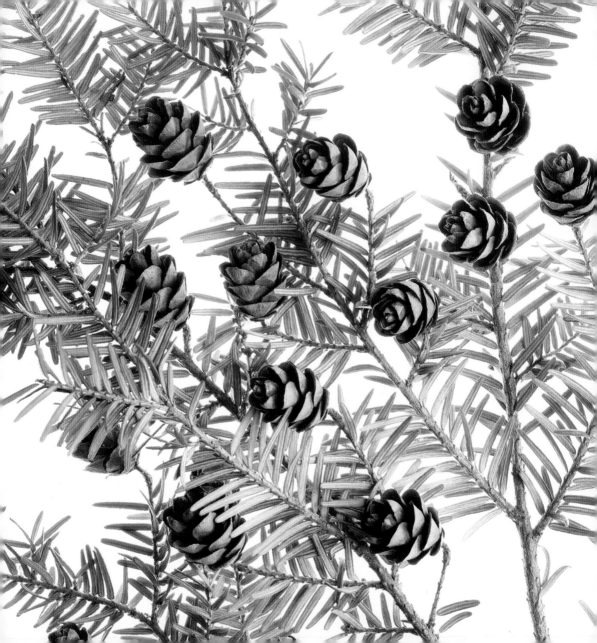

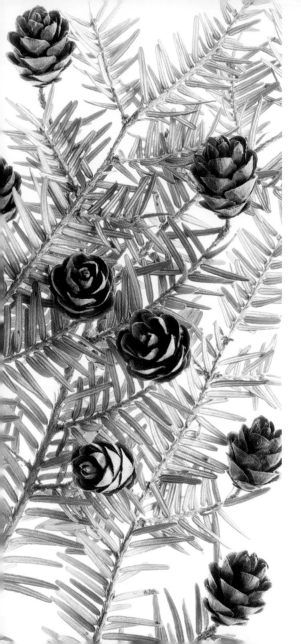

CONTENTS

Small but fully mature female cones of the eastern hemlock (*Tsuga canadensis*) nestle among the needles.

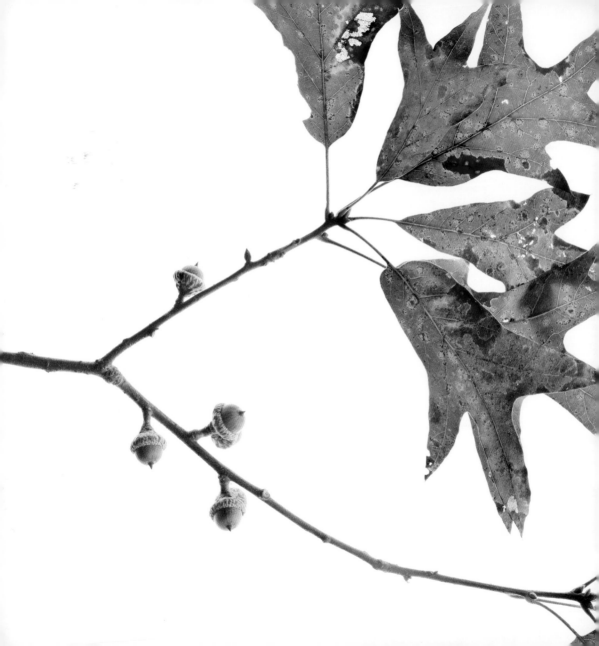

INTRODUCTION

THE REWARDS OF OBSERVING INTIMATE TREE details such as maturing acorns, unfurling beech leaves, and emerging walnut flowers inspired photographer Robert Llewellyn and me to create this book. This kind of tree-watching is different from the kind that takes in trees at a glance, possibly names them, then places them in the category of thing to watch at a certain time, like when they're leafing out in spring or changing color in fall. There is always something to watch when you are paying attention to the intimate details that define tree species and the processes that characterize their life cycles. Like the Chinese, who divide the solar calendar into twenty-four seasons

Distinctive acorns, bristle-tipped leaves, and their associated predators are all part of the gestalt of southern red oak (*Quercus falcata*).

(among them, fortnights called "excited insects," "grains fill," "cold dew," and "frost descends"), a practiced tree-watcher knows there are dozens of seasons, not just four—and that one of them, for example, could be called "acorns plumping out."

In a previous project, Bob and I traveled over 20,000 miles and spent four years describing and illustrating the finest trees in our state, Virginia. For that project, we focused primarily on large, extraordinary trees in beautiful landscapes. But Bob, who came to photography via engineering and has a keen interest in the way things work, began looking more carefully at the constituent parts of the trees we were visiting, and he was soon collecting twigs, flowers, fruits, and buds to examine and photograph in his studio. He knows from long experience that "picking up a camera makes you really see things," and soon he was discovering minute phenomena that further piqued his interest in the way trees work and live. To capture them, he mastered a new form of photography. Using software developed for work with microscopes, Bob creates incredibly sharp images by stitching together eight to forty-five images of each subject, each shot at a different focal point. And, inspired by botanical drawings, he photographs his subjects against a white background, which helps to isolate them and emphasize their detail.

Like a botanical painter, Bob wanted his photographs to "enlighten people about what's going on" in the natural world, but he also wanted to be enlightened himself. As we got into our work, Bob was soon full of questions about the functions of bud scales, fine leaf hairs, and other tree minutiae. He was learning which trees had separate male and female flowers, which had both, and which had "perfect" flowers (flowers with both male and female parts). He was a question machine, and he looked to me, a tree lover from way back, for answers. So I decided my job was to be the bridge between botanists and ordinary tree lovers who were put off by botanical nomenclature but interested—extremely interested—in seeing more and learning more about trees.

Instead of traveling thousands of miles to see exceptional trees, as we had for our first collaboration, Bob and I decided to focus on the exceptional traits of ordinary, backyard trees. We did little traveling (unless you count walks around our own yards and neighborhoods), but we were no less impressed by what we saw. In fact, limiting the descriptions and illustrations of what we saw became harder than finding interesting tree traits to feature.

Our goal in creating this book was to share the beauty of what we discovered and to get other people outdoors searching for tree phenomena like the ones we observed, because what is startling in Bob's photographs is infinitely more inspiring outdoors, where it can be appreciated in context and

with all the senses. And it is in the process of discovering these phenomena in nature that the real joy of tree-watching resides. We want to convey that tree-viewing can be as exciting as bird-watching (perhaps even more exciting, if trees are your favorite wild beings) and that through intimate viewing, one's sense of trees as living, breathing organisms, as opposed to inanimate objects, will be enhanced.

Above all, like most writers and photographers who value what they describe and illustrate, Bob and I hope this book will help make the world safer for trees. In my most romantic imaginings, I sometimes think that if I could just draw enough people's attention to the beauty of red maple blossoms, the extraordinary engineering of gumballs, the intricacy of pine cones—all would be well in the tree world. That *is* a romantic notion. But sometimes romance can accomplish what rhetoric cannot. Look carefully at the hair, veins, pores, and other wildly vivifying tree characteristics captured in the photographs in this book, and you'll never see a tree in the same way again.

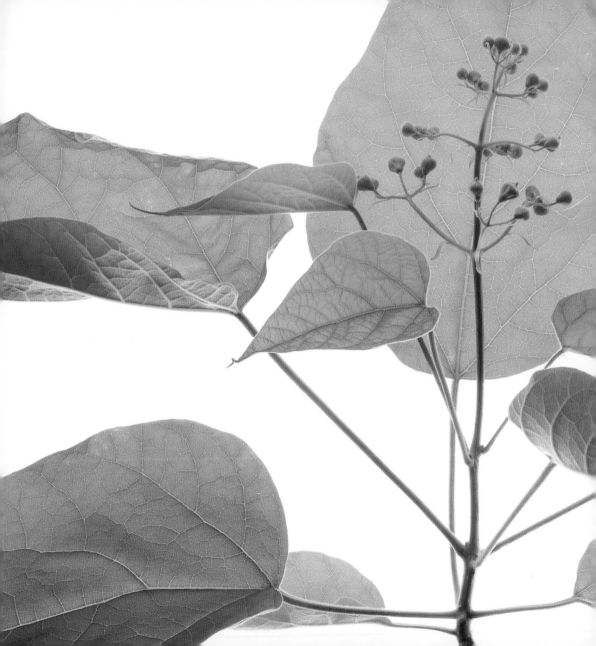

LEAVES

HERE'S THE SHORTEST LEAF TUTORIAL IN THE history of the world: leaves can be simple (one connected piece), compound (a collection of smaller leaflets), or doubly compound (each part of the compound leaf itself a collection of smaller leaflets). Examples of simple leaves include oak, maple, and tulip poplar. Examples of compound leaves include horsechestnut and the closely related buckeye (leaflets arranged around a central point) and locust, walnut, hickory, and ash (leaflets scattered along the main axis of the leaf stalk). Kentucky coffeetree, mimosa, and chinaberry are trees with doubly compound (or bipinnate)

In addition to showy flowers and long, bean-like pods, northern catalpa (*Catalpa speciosa*) is notable for its large, lime-green leaves and shapely flower buds.

leaves, which means that along the main axis of each leaf stalk there is a series of subordinate stalks, each of which is lined with leaflets.

The arrangement of leaves on the twig is another identifying tree feature. The leaves of most tree species, including oaks, alternate along the stem. A few trees have leaves that are positioned opposite each other on the twig, and the most common of these are easily remembered by the mnemonic "Damp Horse," in which the letters of the first word stand for dogwood, ash, maple, and princess tree, and the second word stands for horsechestnut and (by extension) buckeye. Only a very few trees, like catalpas, carry their leaves in a whorled arrangement (three or more leaves distributed regularly around the twig at the same point). In addition to looking at the overall shape of a leaf, look at the shape of its tip, its base, and its edges: all are clues to a tree's identity. Shape, surface texture, fragrance, and vein pattern are other leaf characteristics to look for.

Leaf color is another tree trait we could view more regularly than we do, and it's an activity that should definitely not be limited to the fall. I actually prefer the subtle greens, pinks, and ochres of spring leaves to the blazing colors of fall, and winter is way undervalued for its leaf color. In December, there are russet, red, and scarlet leaves on my oak trees that make some maple reds seem overobvious, and a winter woodland

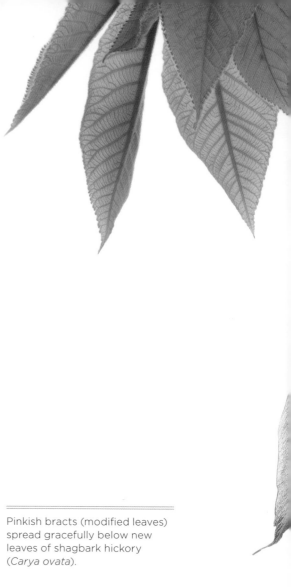

Pinkish bracts (modified leaves) spread gracefully below new leaves of shagbark hickory (*Carya ovata*).

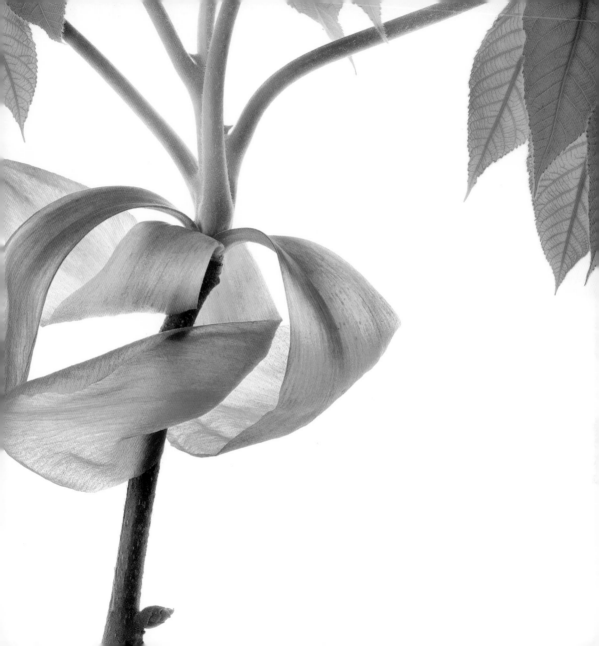

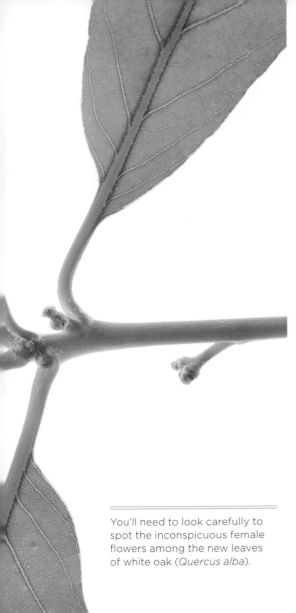

You'll need to look carefully to spot the inconspicuous female flowers among the new leaves of white oak (*Quercus alba*).

dominated by American beech trees is as interesting a color study (all in parchment hues) as the most eye-catching autumn mountainside. From tan to bleached-blonde white, American beech leaves hang on the trees' branches like socks on a clothesline, and they remain there, becoming almost translucent, until early spring. There's a name for these old leaves that stay on the trees until a strong wind or new spring leaves push them off—marcescent. Contrary to popular belief, leaves of this type do not stay on the tree just to irritate obsessive rakers. No one knows for sure why some trees are marcescent and others aren't, but it probably has something to do with protecting the buds below the leaves.

I've made many a leaf collection based on color, but I do it in my hand as I walk, instead of on paper. I arrange the leaves like a hand of cards, slipping a yellow tulip poplar leaf in here, tucking an amber hickory leaf in there, until I hold a wide spectrum of leaf color. In this collection, a dark maroon sweetgum leaf becomes as valuable as the ace of spades, a blue leaf as exciting as a wild card. You can cheat with evergreen needles, but if you look hard enough, you can actually find a few leaves, like those of the maple-leaved viburnum (okay, it's a shrub) and those of the silver maple (undersides only) that are bluish. You can also make a pretty good collection of colored leaves from sweetgum trees alone, because their

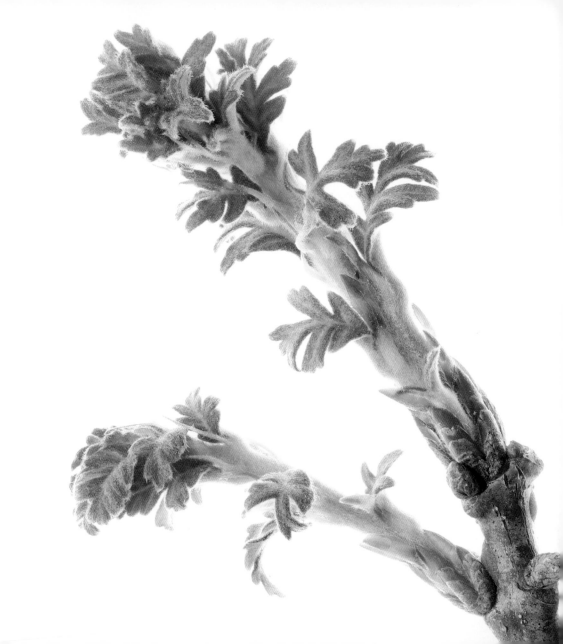

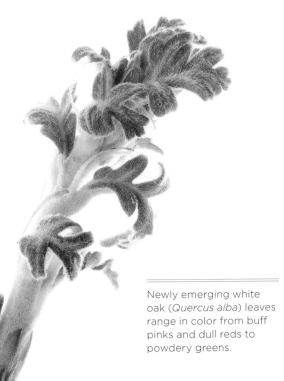

Newly emerging white oak (*Quercus alba*) leaves range in color from buff pinks and dull reds to powdery greens.

fall colors range from yellows, reds, and oranges to an almost black maroon.

As for fall leaves, here are some strategies for seeing them in new ways. First, think of fall as a verb, not a noun. The action of leaves in air, when they're falling, provides the most compelling images of this season. As they move between limb and ground, the air becomes animated, and you can see how, depending on their construction, leaves twist, twirl, float, or spin in the air. The float of a big maple leaf is different from the pinwheel twirl of a sycamore leaf, and the whoop-de-do of an elm leaf caught in an updraft (leaves sometimes fall up!) is entirely different from a thud of mulberry leaves brought down by rain. You can't plan for real fall—as in, "Let's go see the fall leaves this weekend." Real fall, the verb, happens when the wind kicks up, creating a shower of willow oak leaves or a frost loosens the latches of the ginkgo leaves.

To experience the idiosyncrasies of falling leaves on a visceral level, try catching them. "Every leaf you catch in October means a happy month next year," I once read, and I've made it my business to catch twelve leaves in that month ever since. It's harder than you think, nabbing leaves from the air. Football coaches would do well to have their wide receivers practice leaf-catching, so unpredictable are airborne leaves in their flights. (The higher up in the tree they start, the more rewarding the catch.) ❖

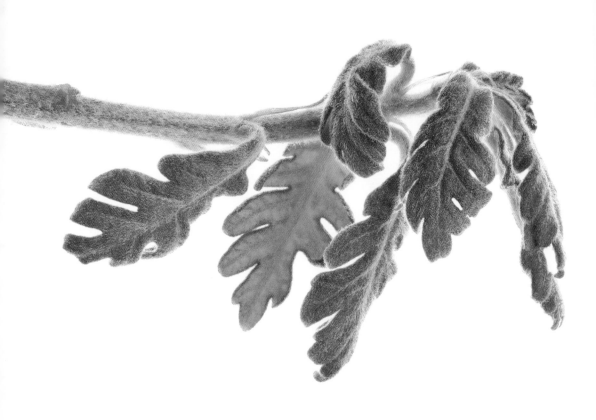

Young leaves of white oak (*Quercus alba*) have a soft, hairy pubescence that helps them retain moisture.

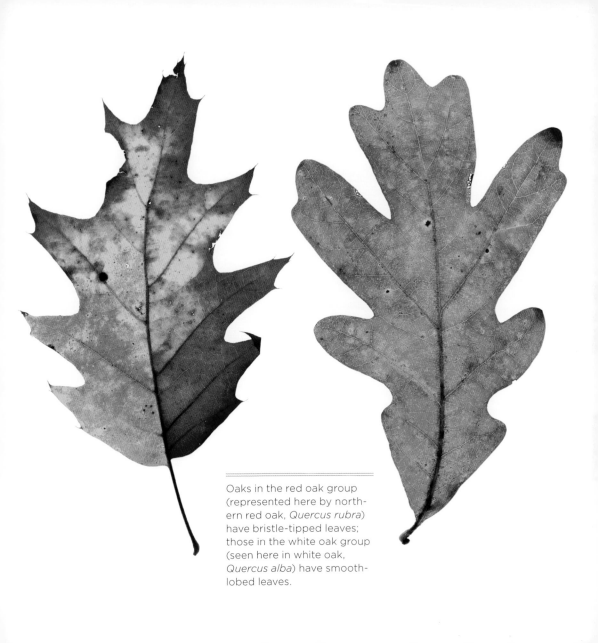

Oaks in the red oak group (represented here by northern red oak, *Quercus rubra*) have bristle-tipped leaves; those in the white oak group (seen here in white oak, *Quercus alba*) have smooth-lobed leaves.

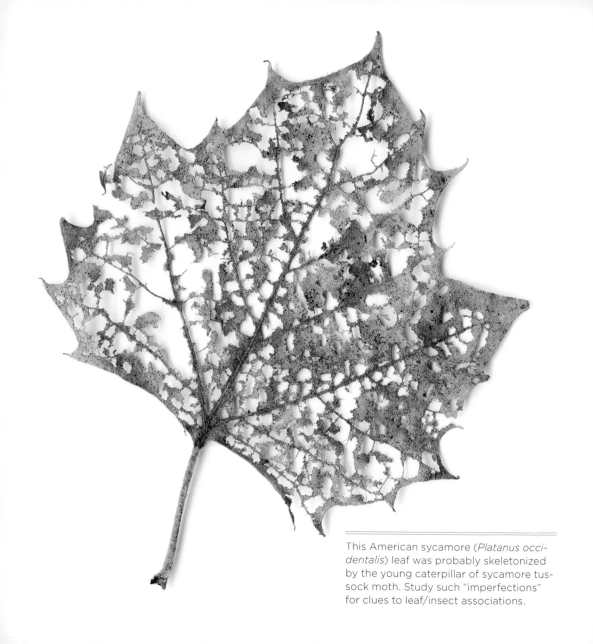

This American sycamore (*Platanus occidentalis*) leaf was probably skeletonized by the young caterpillar of sycamore tussock moth. Study such "imperfections" for clues to leaf/insect associations.

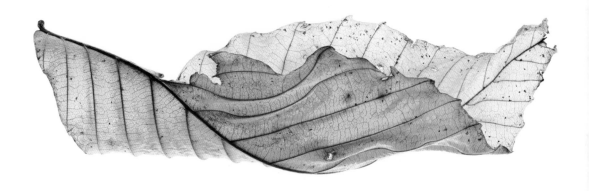

The marcescent leaves of American beech (*Fagus grandifolia*) are often tissue-thin before falling from the trees in early spring.

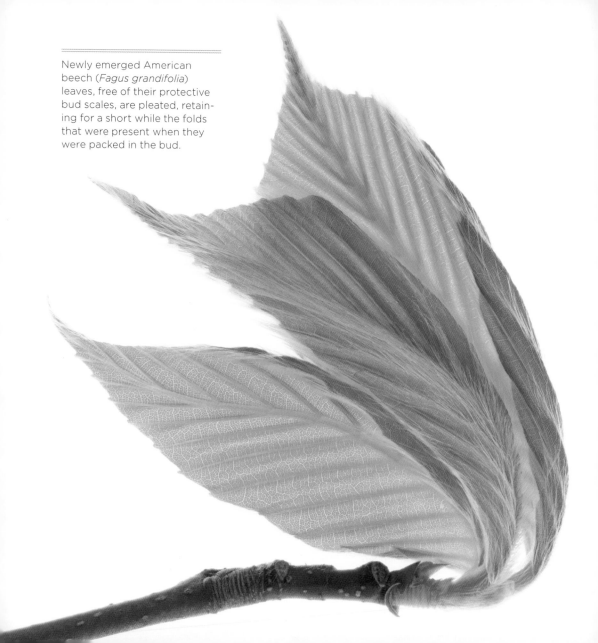

Newly emerged American beech (*Fagus grandifolia*) leaves, free of their protective bud scales, are pleated, retaining for a short while the folds that were present when they were packed in the bud.

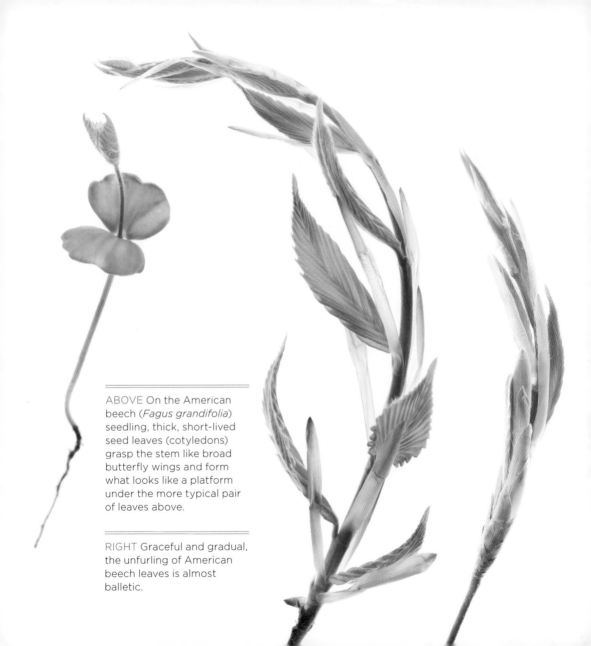

ABOVE On the American beech (*Fagus grandifolia*) seedling, thick, short-lived seed leaves (cotyledons) grasp the stem like broad butterfly wings and form what looks like a platform under the more typical pair of leaves above.

RIGHT Graceful and gradual, the unfurling of American beech leaves is almost balletic.

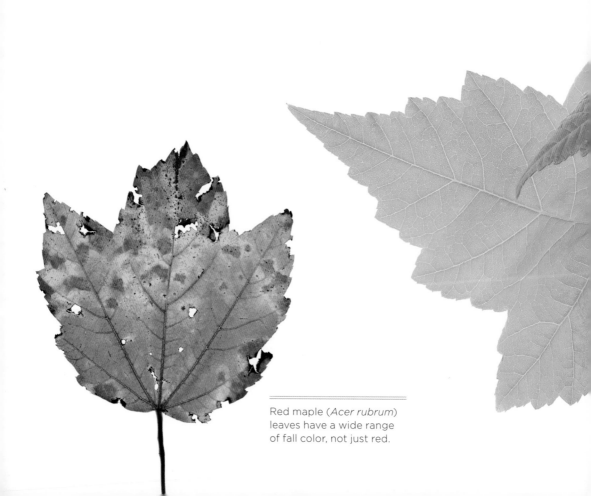

Red maple (*Acer rubrum*)
leaves have a wide range
of fall color, not just red.

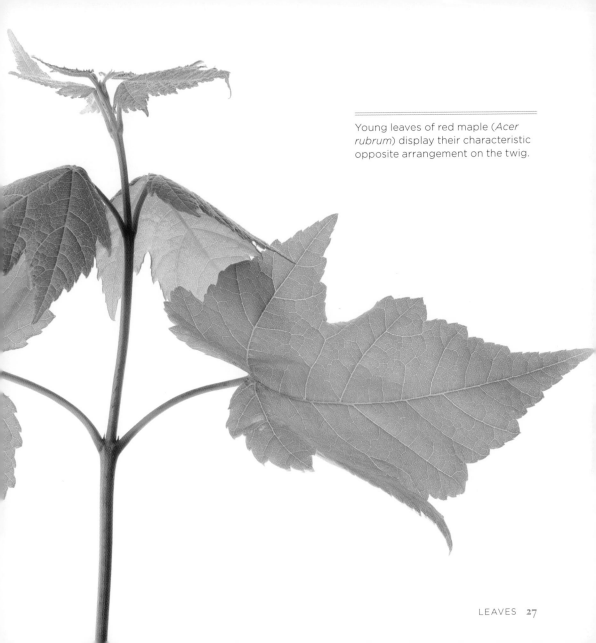

Young leaves of red maple (*Acer rubrum*) display their characteristic opposite arrangement on the twig.

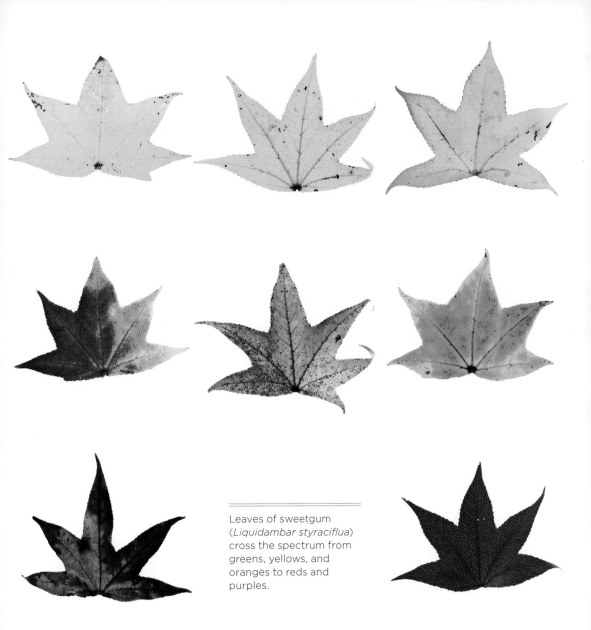

Leaves of sweetgum (*Liquidambar styraciflua*) cross the spectrum from greens, yellows, and oranges to reds and purples.

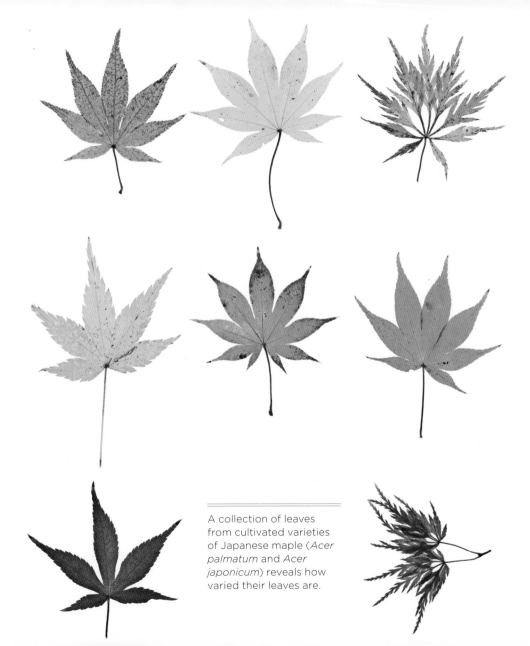

A collection of leaves from cultivated varieties of Japanese maple (*Acer palmatum* and *Acer japonicum*) reveals how varied their leaves are.

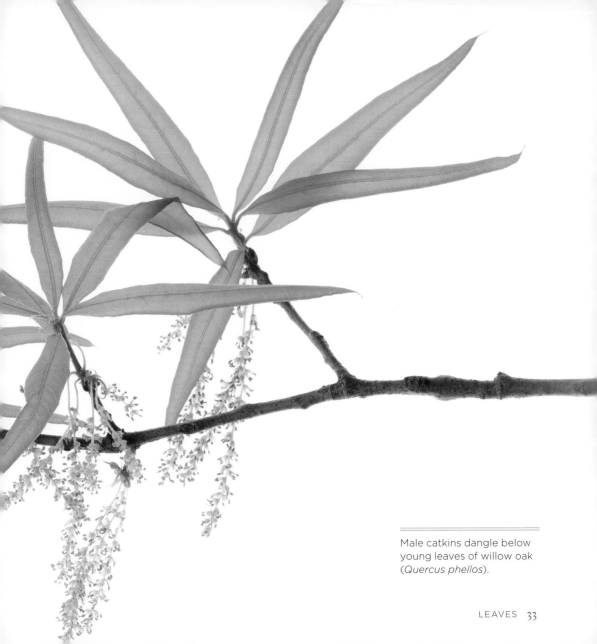

Male catkins dangle below young leaves of willow oak (*Quercus phellos*).

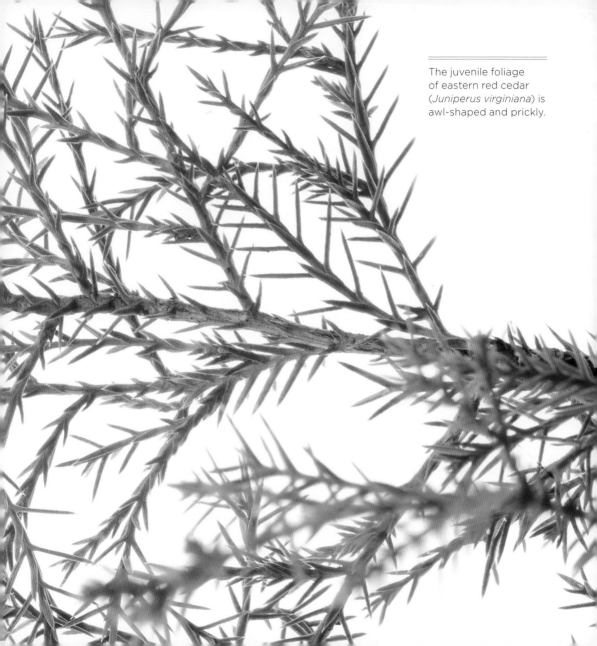

The juvenile foliage
of eastern red cedar
(*Juniperus virginiana*) is
awl-shaped and prickly.

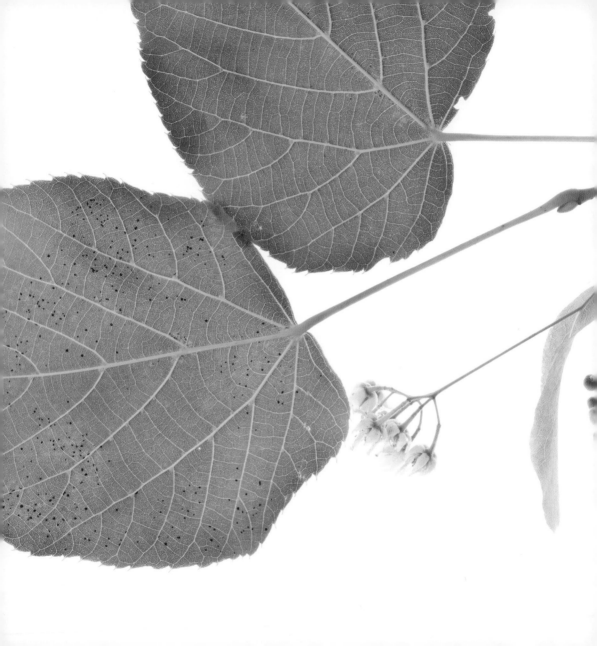

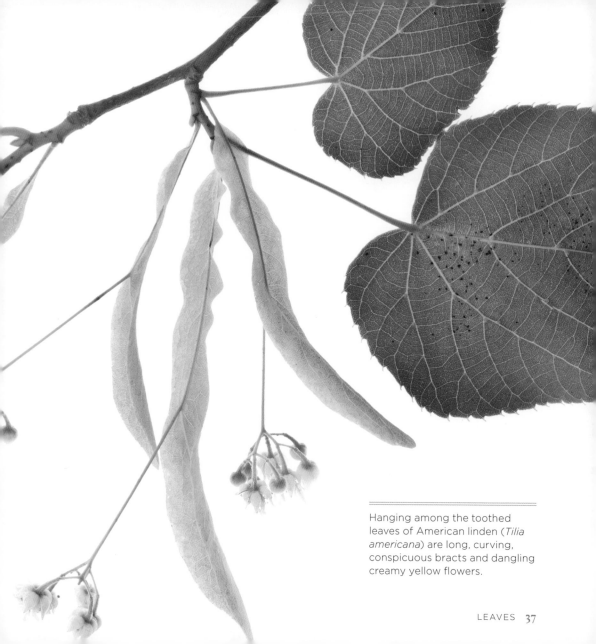

Hanging among the toothed leaves of American linden (*Tilia americana*) are long, curving, conspicuous bracts and dangling creamy yellow flowers.

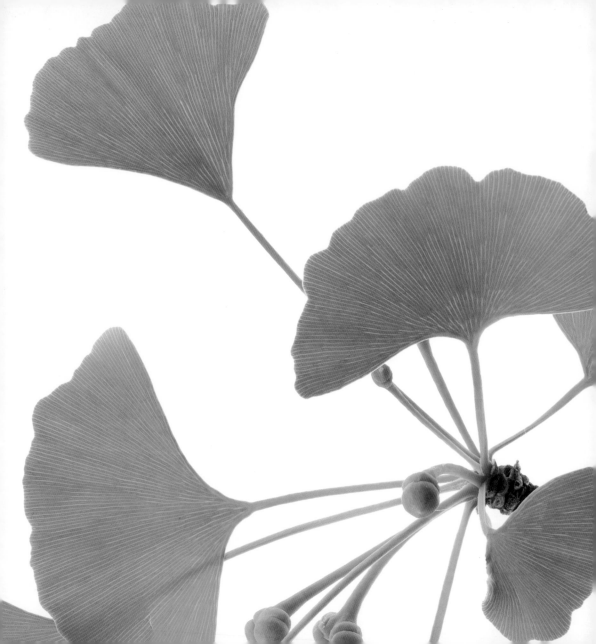

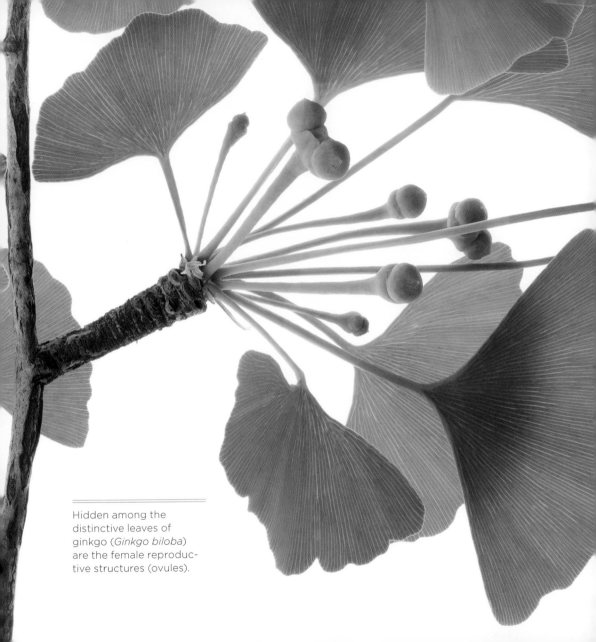

Hidden among the distinctive leaves of ginkgo (*Ginkgo biloba*) are the female reproductive structures (ovules).

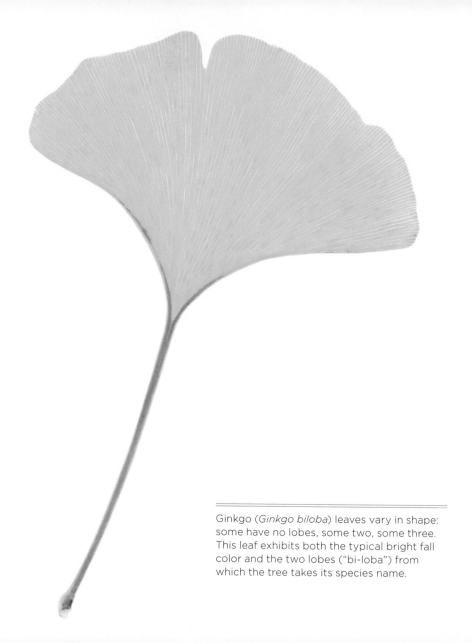

Ginkgo (*Ginkgo biloba*) leaves vary in shape: some have no lobes, some two, some three. This leaf exhibits both the typical bright fall color and the two lobes ("bi-loba") from which the tree takes its species name.

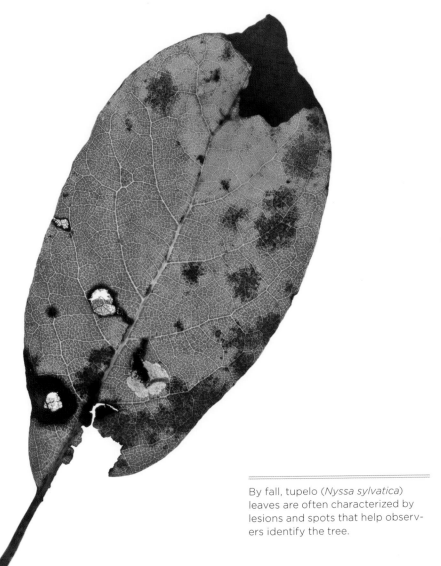

By fall, tupelo (*Nyssa sylvatica*) leaves are often characterized by lesions and spots that help observers identify the tree.

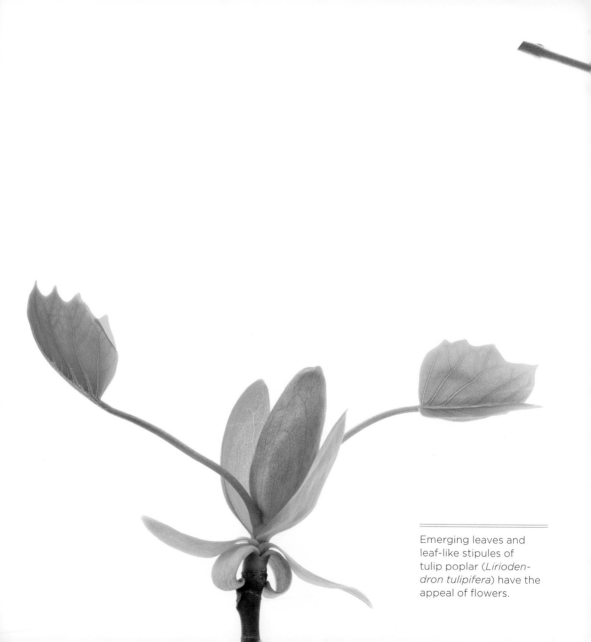

Emerging leaves and
leaf-like stipules of
tulip poplar (*Lirioden-
dron tulipifera*) have the
appeal of flowers.

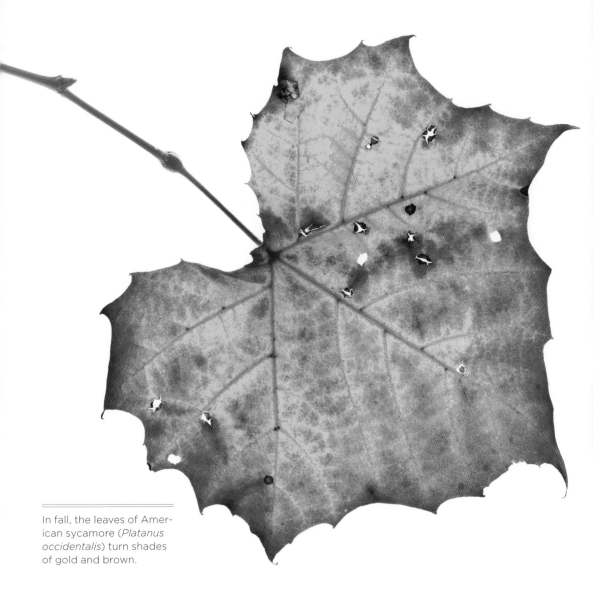

In fall, the leaves of American sycamore (*Platanus occidentalis*) turn shades of gold and brown.

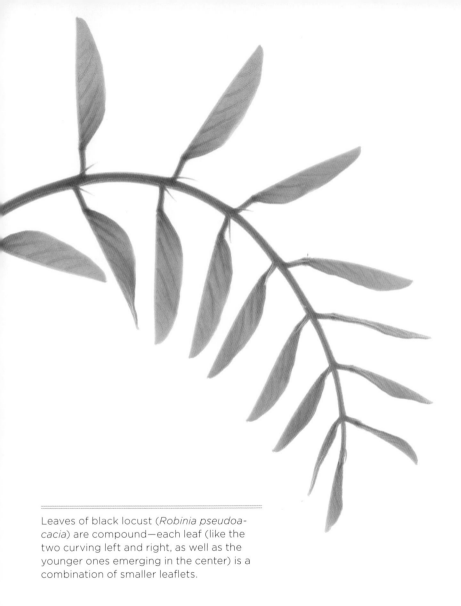

Leaves of black locust (*Robinia pseudoacacia*) are compound—each leaf (like the two curving left and right, as well as the younger ones emerging in the center) is a combination of smaller leaflets.

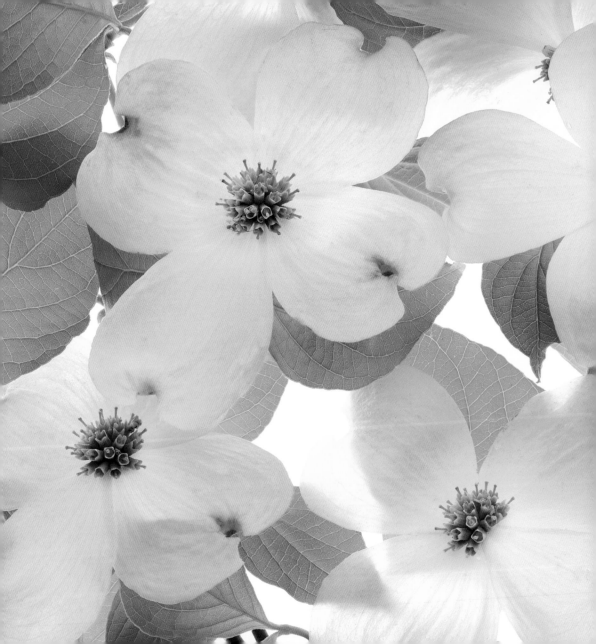

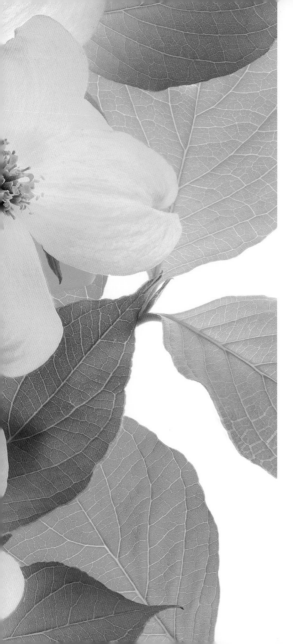

FLOWERS & CONES

IT COMES AS A SHOCK TO MANY PEOPLE THAT most North American trees even have flowers. We celebrate our cherry blossoms and prize a few other ornamental flowering trees like the magnolia, but ask the average person to picture an oak, ash, sweetgum, or maple flower and you will probably get a blank stare. It's true, though: with the exception of trees that bear cones (and a few other related trees), all North American trees have flowers. So why are we so unaware of them? The "invisibility" of most North American tree flowers relates to the fact that many are pollinated

A favorite landscape tree throughout its range (most of the eastern United States and parts of Canada), flowering dogwood (*Cornus florida*) offers four-season beauty, but its spring blooms are particularly noteworthy.

by wind, not animals, and so they don't need to be conspicuous.

The function of conspicuous flowers is to attract animal pollinators (primarily insects), and like most garden flowers, conspicuous tree flowers do just that. The flowers of northern catalpa, for example, are not only showy enough to attract bees, but they have purple lines on them, directing bees to the nectar inside. And the conspicuous flowers of the tulip poplar are all decked out in orange and yellow not to impress human beings but to lure bees. If you're not advertising yourself to pollinators, however, such fancy dressing is a waste of energy.

The flowers of wind-pollinated trees (oak, willow, alder, walnut, beech, ash, sweetgum, boxelder, birch, elm, aspen, cottonwood, hickory, mulberry) are known for many things but not for large, conspicuous flowers. Maples, which are both wind- and insect-pollinated, also have small, relatively inconspicuous flowers. This is not to say, however, that the flowers of the maple or other inconspicuous tree flowers aren't gorgeous. Because they are not always easy to see, one part of their charm lies in finding them, another lies in observing them up close (many of their forms are as dramatic as those of conspicuous, animal-pollinated flowers), and yet another lies in their repetition. You may, for example, have observed the flowers of more wind-pollinated tree flowers than you think, if you have witnessed the red tops of red maples in early

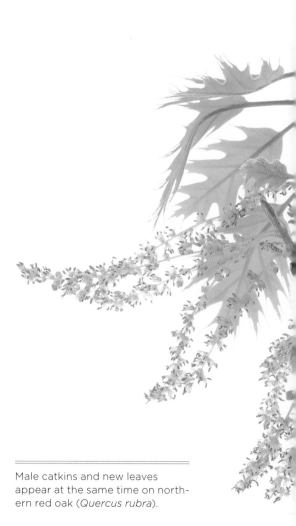

Male catkins and new leaves appear at the same time on northern red oak (*Quercus rubra*).

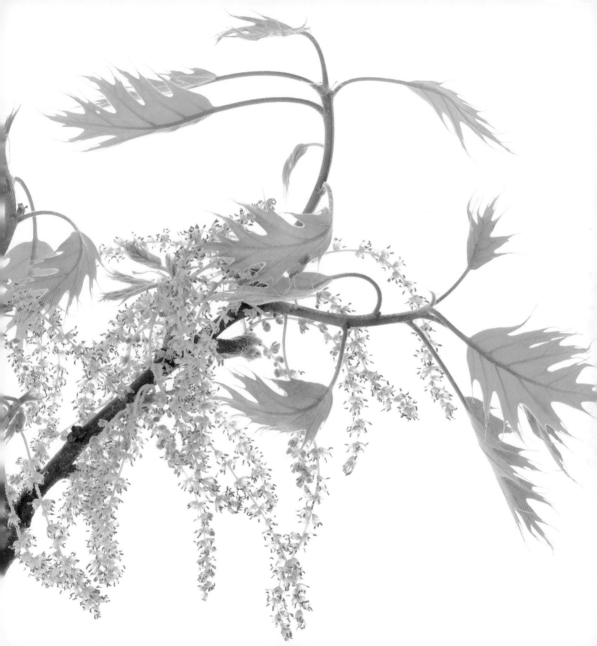

spring (that red is the tree's flowers, not its leaves), observed the first pale greenish red tinge in the canopy of an American elm (that color is coming from dangling, earring-like flowers), or spotted an intensely yellow male weeping willow (when its spring catkins are loaded with pollen). This brings me to another characteristic of most wind-pollinated trees: they have flowers that are either male or female, as opposed to having flowers with both male and female parts as most (but not all) animal-pollinated flowers do.

When searching for tree flowers, it is important to know that some trees bear only male flowers, some bear only female flowers, some bear both male flowers and female flowers, and some bear "perfect" flowers, which have both male and female parts. You can find out which tree species have which flower arrangements by consulting a good field guide or appropriate website. Having that information is invaluable, not only in helping you know what you're looking for but in interpreting what you eventually see. Beech and oak trees, for example, have separate male and female flowers on the same tree (that is, individual trees of each species bear flowers of both sexes); white ash and willow trees have separate male and female flowers, but they are usually on different trees (that is, individual trees of either species usually bear only male or only female flowers); magnolias, serviceberries, and elms have

Female cones and male catkins appear on the same twig of smooth alder (*Alnus serrulata*).

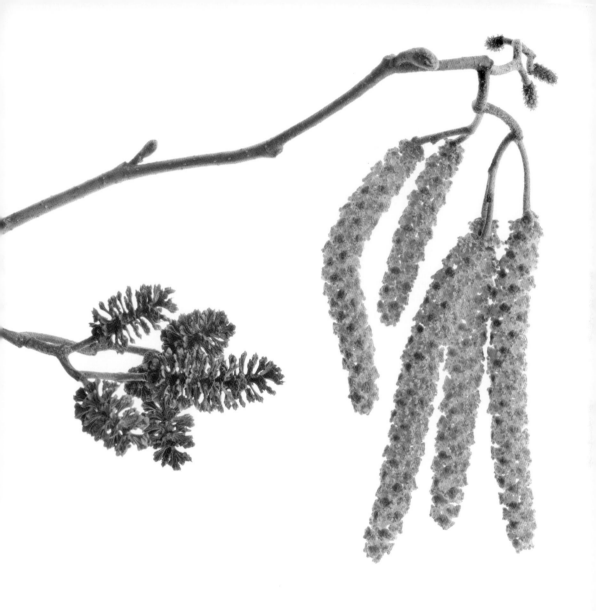

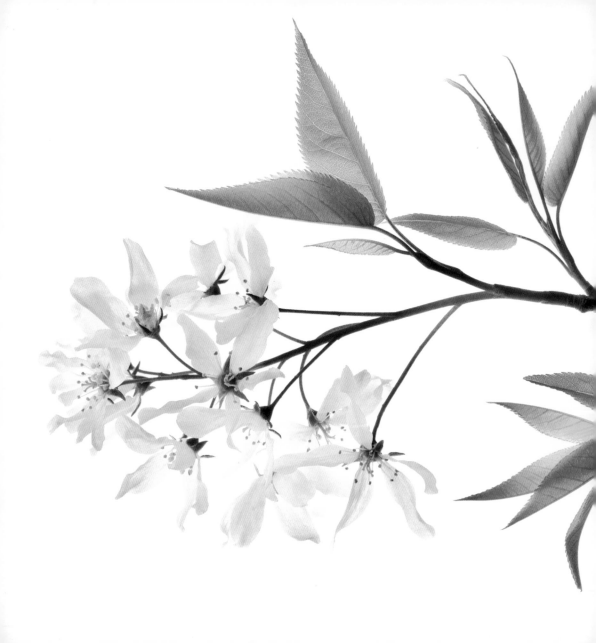

perfect flowers, with each individual flower possessing both male and female parts. Tree-watchers can have a fine time observing tree flowers without ever telling a pistil (female flower part) from a stamen (male flower part), but the more you know about the reproductive parts of flowers, the more informed your observations will be. It's one thing, for instance, to be able to tell a male from a female walnut flower (not too difficult, because the female flower is a furry, fruity thing, the male flowers hang in catkins), but it's something else to appreciate why the tip of the female flower has enlarged, sticky stigmatic surfaces (the better to catch airborne pollen).

There is also an entire category of trees, the gymnosperms, that don't have flowers but do have flower-like structures that are interesting to observe. From an evolutionary point of view, the gymnosperms, which include, among other trees, the pine, spruce, fir, hemlock, and red cedar, are older than the angiosperms (the flowering trees) and their reproductive structures are quite different. Their defining difference is the fact that they have "naked seeds"—there is no fruit tissue surrounding their seeds—but this discrimination is more relevant to botanists than backyard tree-watchers. To the backyard observer, the interesting thing about the gymnosperms (or at least the subset we know as conifers) is that most are evergreen, most have needles, and all have cones.

Flowers like these serviceberry (*Amelanchier* species) flowers are considered "perfect" because they have both male and female parts.

Conifers produce quite different male and female cones, which are usually on the same tree. What most of us think of as cones are the female cones of a conifer—the woody structures, like the archetypal pine cone, that persist on the tree for at least a year (and on some conifers, for over a decade) and in which the tree's seeds develop. The structure of female cones, as well as their position on the branch, varies among conifers and is one of the features used to identify them. Female cone shapes vary from almost round to torpedo-like, and their sizes range from that of a small olive to a small football. Their orientation to the branch also varies: the female cones of the spruce, for example, hang down, while the female cones of the fir point up. Immature female cones are usually smaller, greener, and softer versions of their grown-up selves and they have a more succulent, fleshy texture, but with age female cones take on the hard texture, browner color, and woody look we expect of them.

Most people don't see, or at least don't recognize, male conifer cones as what they are, because they aren't woody and don't fit our expectations of what cones should look like. Male conifer cones, often referred to as pollen cones, are usually much smaller and stubbier than female cones, they are simpler in structure, and they are much more numerous. There is a rice grain–sized male pollen cone, for example, at the tip of almost every male red cedar branchlet. Compared to female

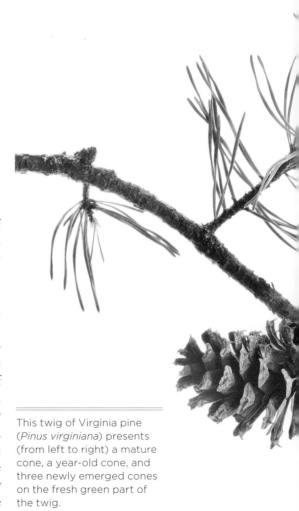

This twig of Virginia pine (*Pinus virginiana*) presents (from left to right) a mature cone, a year-old cone, and three newly emerged cones on the fresh green part of the twig.

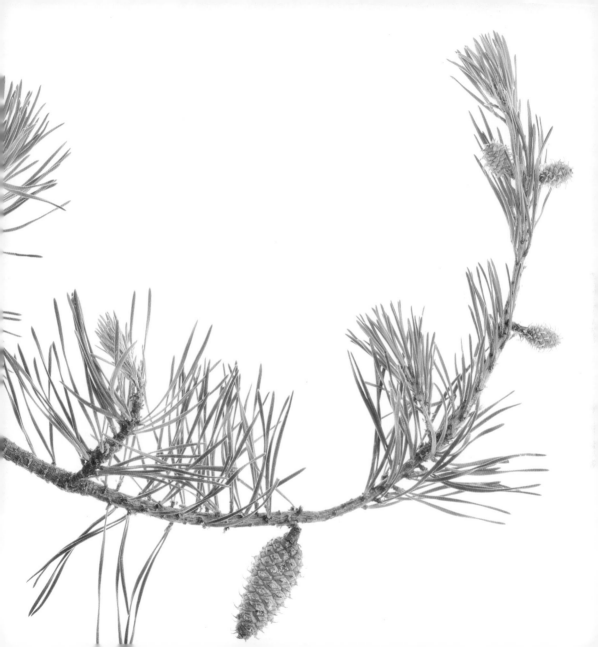

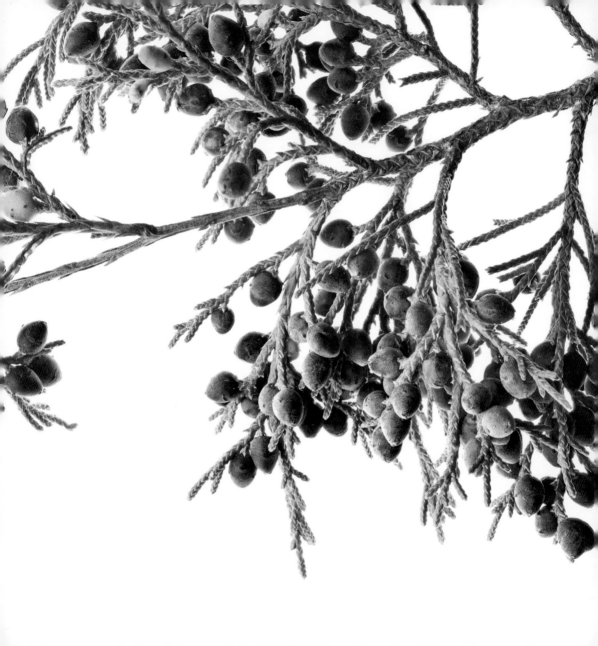

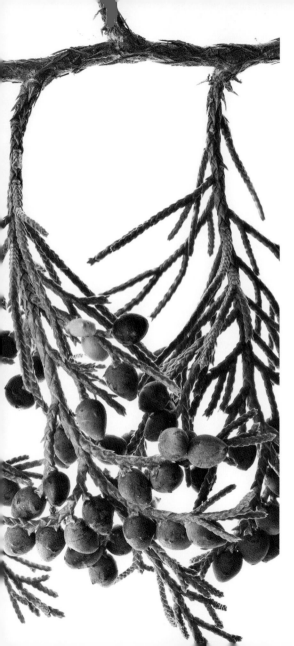

seed cones, male pollen cones are relatively short-lived, usually falling from the tree and quickly deteriorating as soon as they have released their pollen. As with female cones, it is almost impossible to generalize about the shape of male pollen cones, but many look like a cross between a pussy willow catkin and a miniature ear of corn. Some appear singly but others appear in clusters, making them look almost like flowers. The colors of immature pollen cones vary from green to brown to purple to yellow to reddish, but when mature and loaded with pollen, they all look yellow or orange. ❖

Female eastern red cedars (*Juniperus virginiana*) are loaded with "berries" (technically cones with fleshy scales), which progress from a pale frosted blue-green, to steel blue, to bluish black.

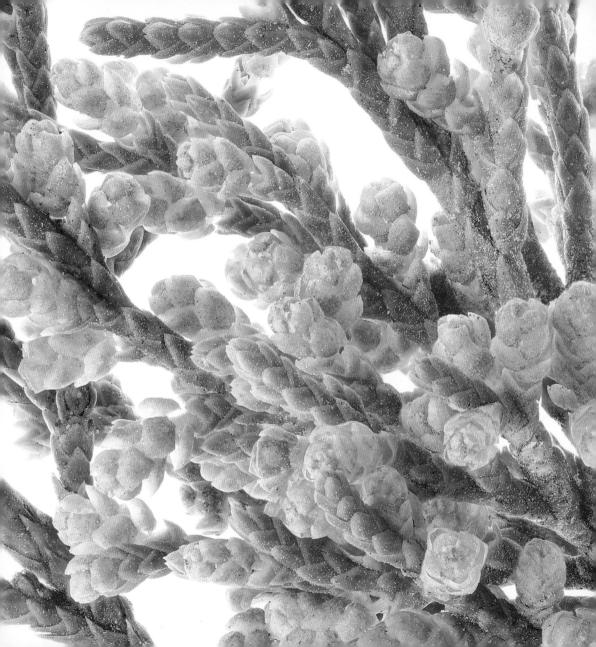

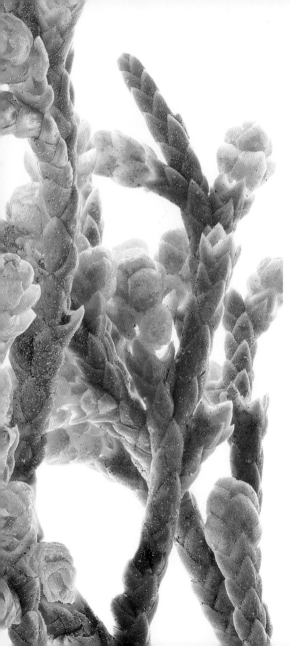

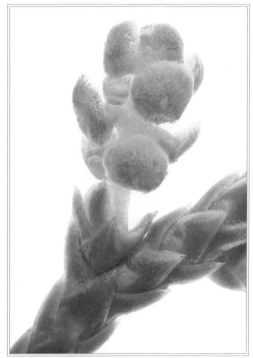

In this magnified view of an eastern red cedar (*Juniperus virginiana*) pollen cone, the chambers, which have released their pollen, are visible.

LEFT Pollen cones are responsible for some of the bronzy spring color of male eastern red cedars.

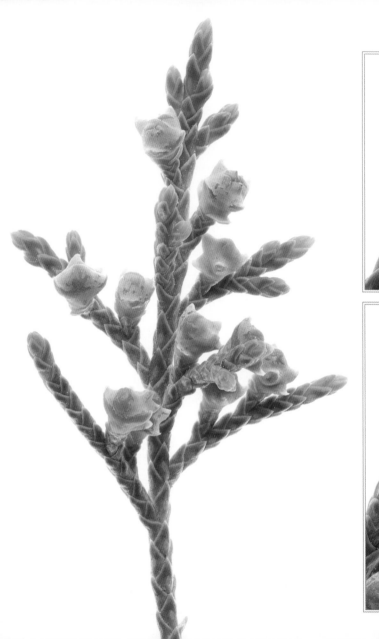
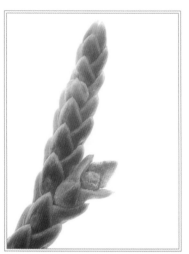
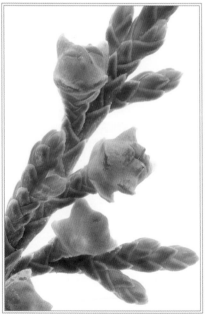

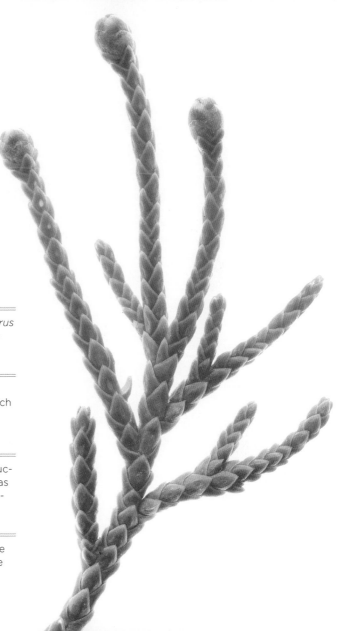

RIGHT Male eastern red cedars (*Juniperus virginiana*) produce tiny pollen cones at the tips of their branchlets.

FAR LEFT Female eastern red cedars produce female cones, or "berries," which are particularly interesting and seldom observed in their very early stages.

TOP LEFT The female reproductive structure of eastern red cedar is first visible as it emerges from the tree's scale-like foliage in late winter.

LEFT Fleshy scales, which will give it the appearance of a berry, cover the female eastern red cedar cone.

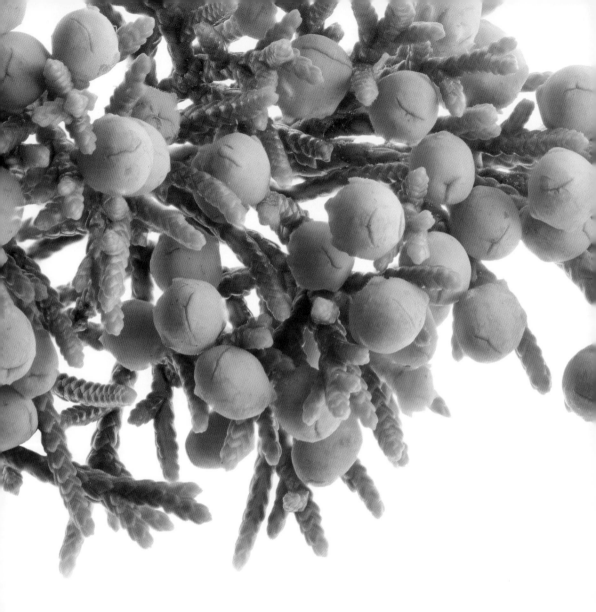

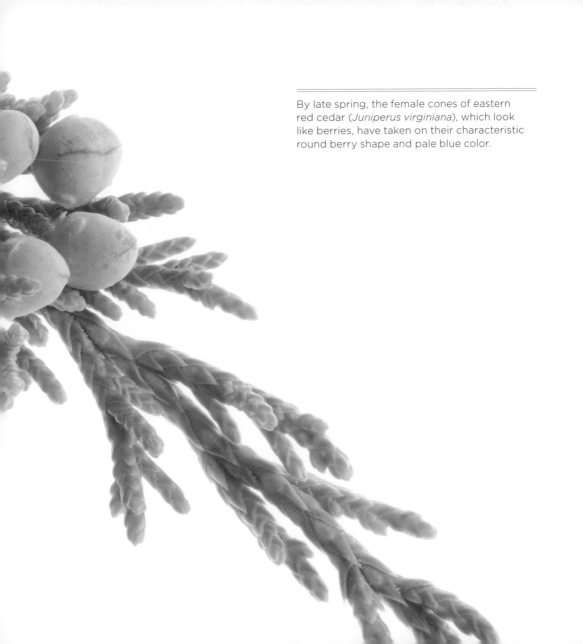

By late spring, the female cones of eastern red cedar (*Juniperus virginiana*), which look like berries, have taken on their characteristic round berry shape and pale blue color.

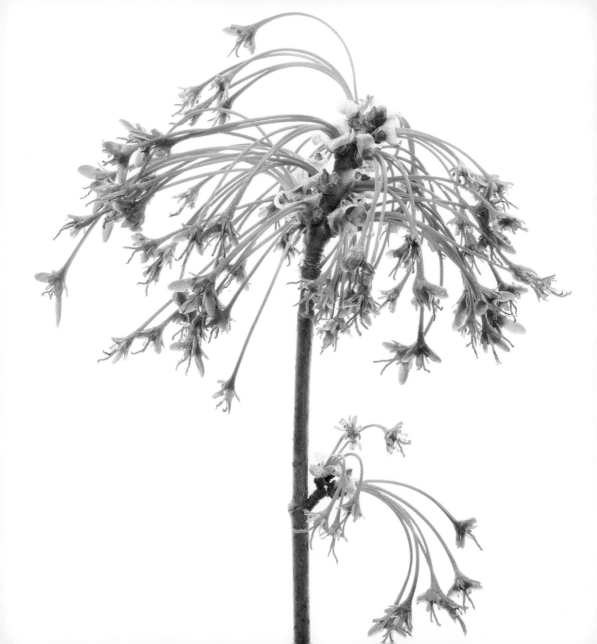

BELOW Anthers (the dark brown tips on the pinkish filaments) of these male red maple flowers are releasing pollen.

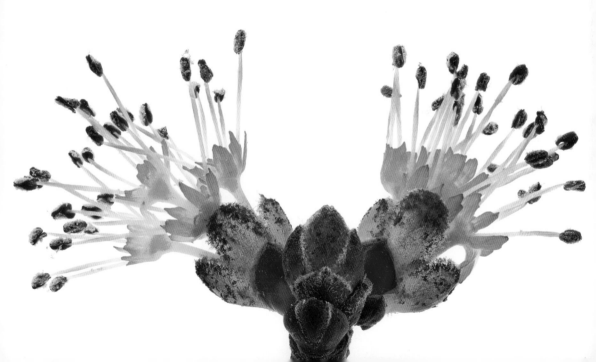

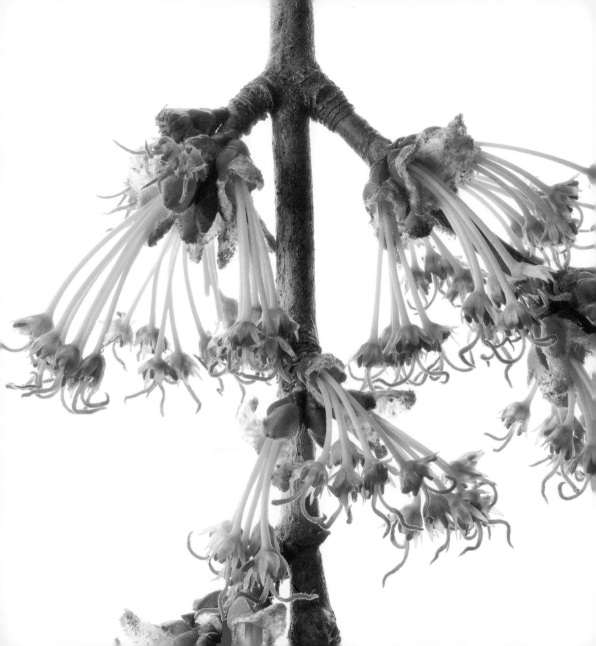

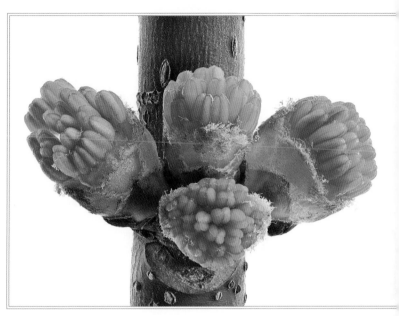

Anthers emerging from immature male red maple (*Acer rubrum*) flowers look like tightly packed hot dog buns (although they're tiny and red!).

LEFT Antennae-like stigmas protrude from these female red maple flowers. At this stage, the flowers' elongated stalks (pedicels) are green; they get redder as they mature.

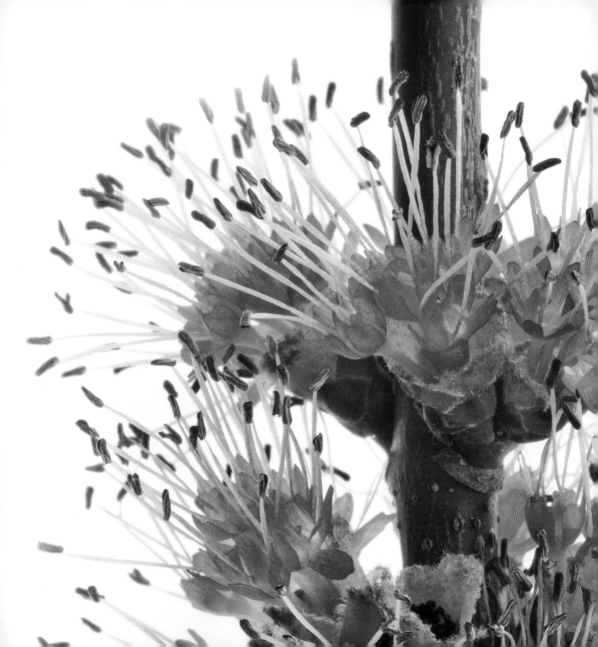

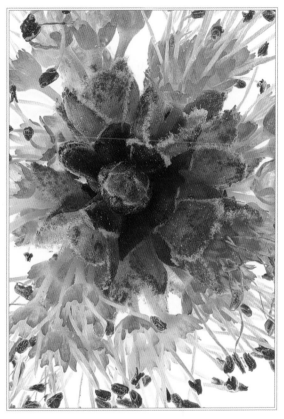

The male flowers of red maple (*Acer rubrum*) are attractive to the naked eye, but they are spectacular under magnification.

LEFT Dark brown anthers top pale filaments that rise above the petals and sepals of clustered male red maple flowers.

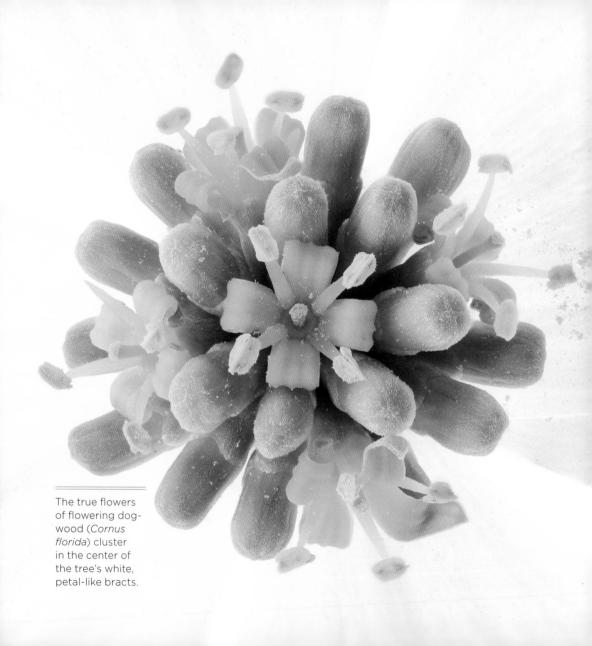

The true flowers of flowering dog- wood (*Cornus florida*) cluster in the center of the tree's white, petal-like bracts.

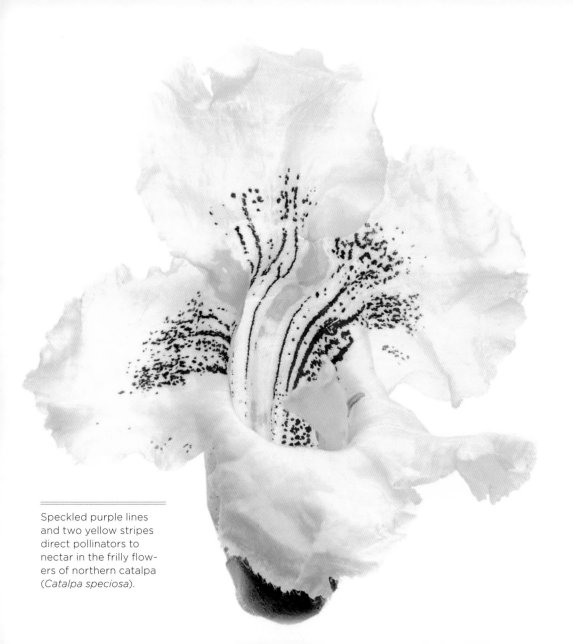

Speckled purple lines and two yellow stripes direct pollinators to nectar in the frilly flowers of northern catalpa (*Catalpa speciosa*).

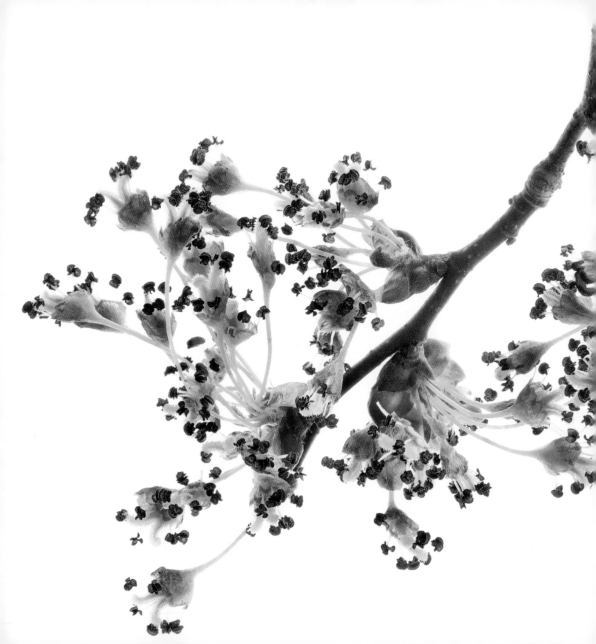

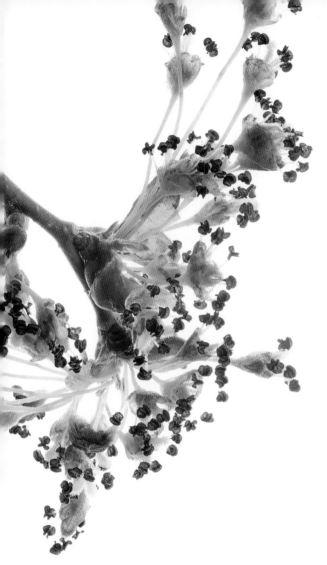

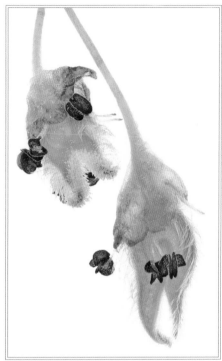

This close-up of two American elm (*Ulmus americana*) flowers shows each flower's male and female parts.

LEFT Flowers, not new leaves, create the first greenish red color in the canopies of American elm in early spring.

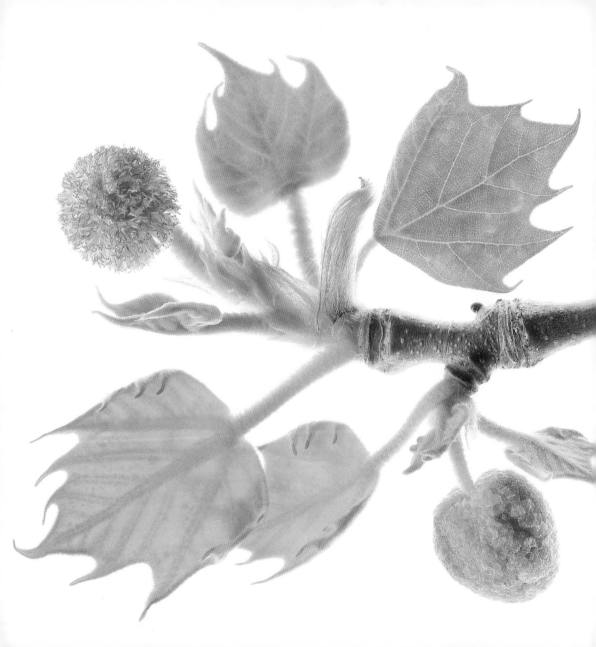

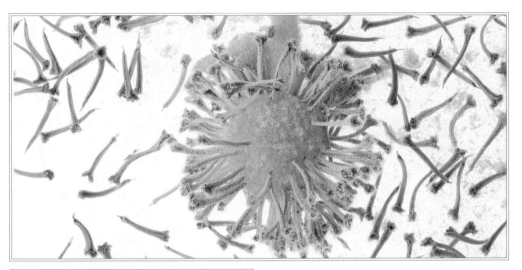

Male American sycamore (*Platanus occidentalis*) flowers drop off following pollen release.

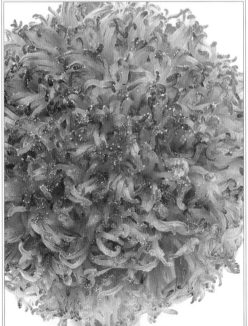

LEFT Reddish stigmas receiving pollen are clearly visible in this close-up of female American sycamore flowers.

FAR LEFT On this twig, female flowers of American sycamore appear in the reddish ball, male flowers in the greenish ball.

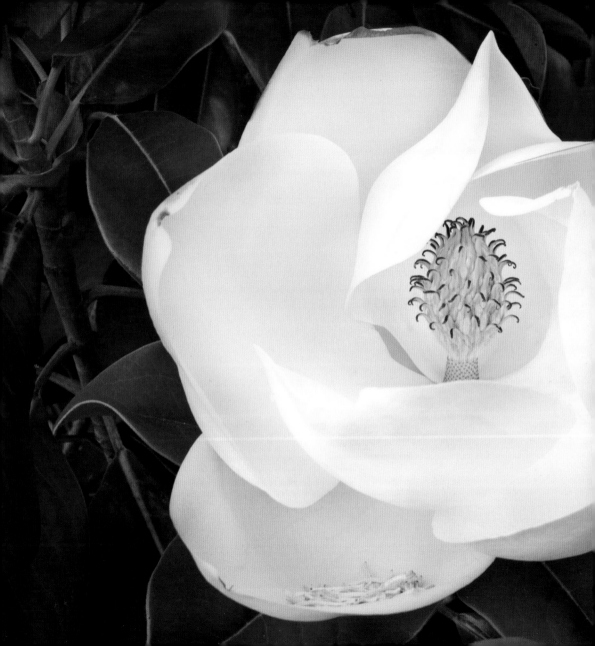

LEFT Large in size and reputation, southern magnolia (*Magnolia grandiflora*) flowers get lots of attention, but many of this flower's subtle details, like the way its discarded stamens collect in its cupped petals, are often overlooked.

BELOW The southern magnolia cone (technically a follicetum) turns shades of blushing pink in early fall.

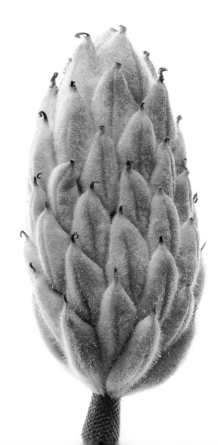

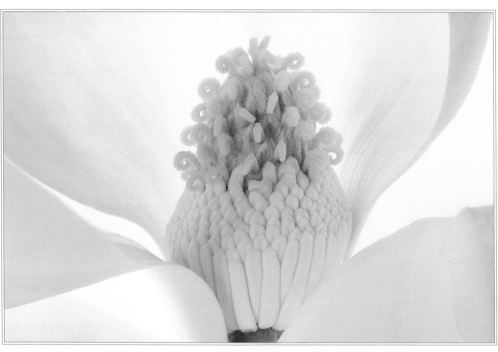

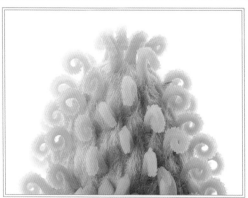

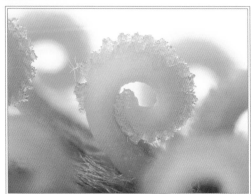

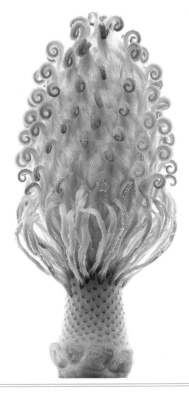

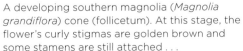

A developing southern magnolia (*Magnolia grandiflora*) cone (follicetum). At this stage, the flower's curly stigmas are golden brown and some stamens are still attached . . .

Later in the cone's development, the flower's curly stigmas are dark brown and all stamens have dropped.

OPPOSITE TOP As southern magnolia flowers develop, curly stigmas emerge from the top half of the floral axis as strap-like stamens develop below.

OPPOSITE LEFT Curly stigmas and the hairy covering of southern magnolia ovaries are clearly visible in this close-up.

OPPOSITE RIGHT This magnified view reveals the sticky surfaces of southern magnolia stigmas, which help capture pollen.

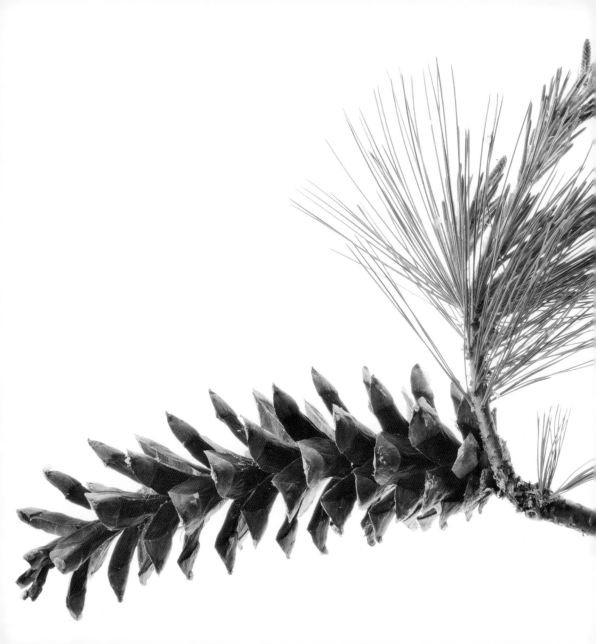

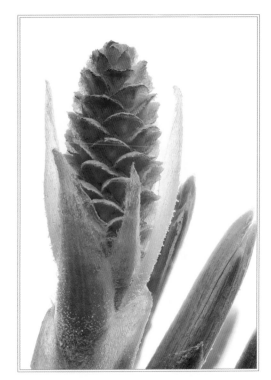

A magnified view of the newly emerging female cones of white pine (*Pinus strobus*) reveals the "rosy lips" of these cones, which some observers refer to as flowers.

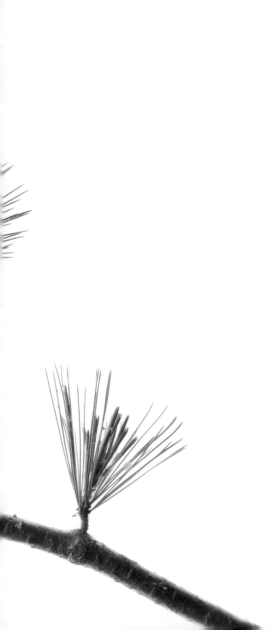

LEFT A two-year-old mature cone and several immature female cones are borne on this white pine twig. The tiny female cones are emerging from new needle and shoot growth in the center of the photo.

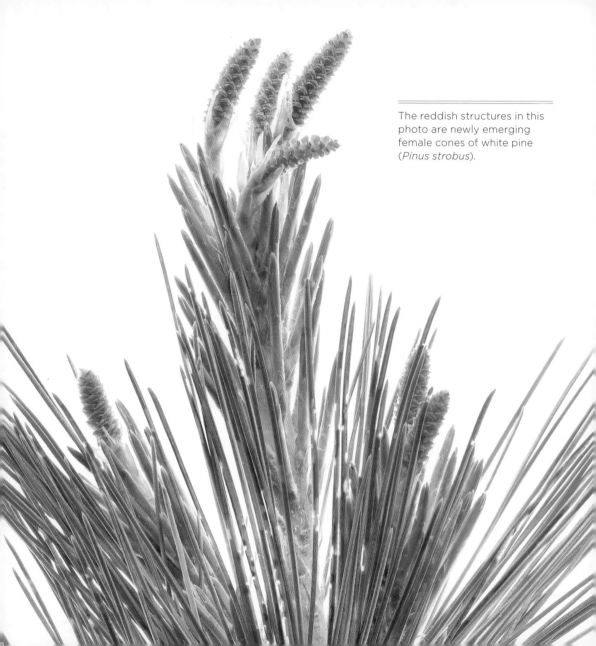

The reddish structures in this photo are newly emerging female cones of white pine (*Pinus strobus*).

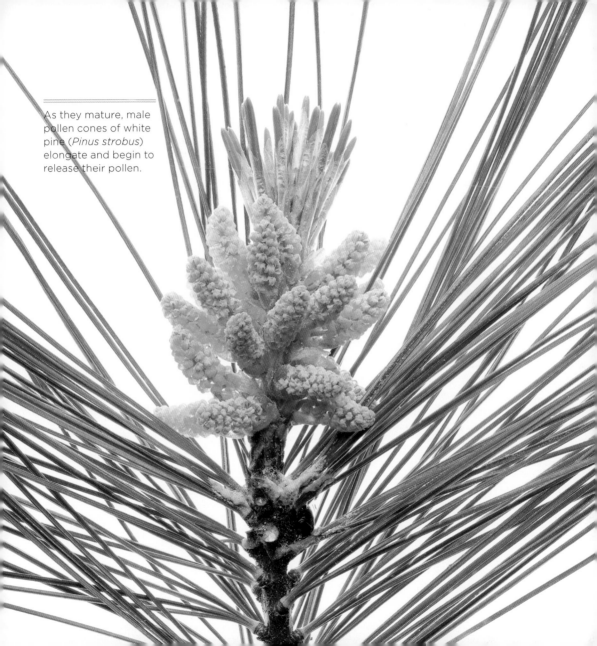

As they mature, male pollen cones of white pine (*Pinus strobus*) elongate and begin to release their pollen.

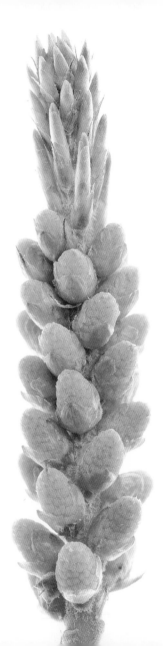

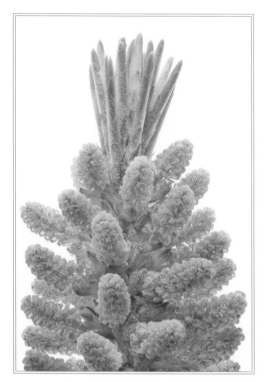

This magnified view shows the individual pollen sacs of white pine (*Pinus strobus*) pollen cones, nearly all of which have split open and released their pollen.

LEFT Immature male pollen cones aggregate along a white pine stem from which new needles are also emerging (at top). Together, they resemble miniature pineapples.

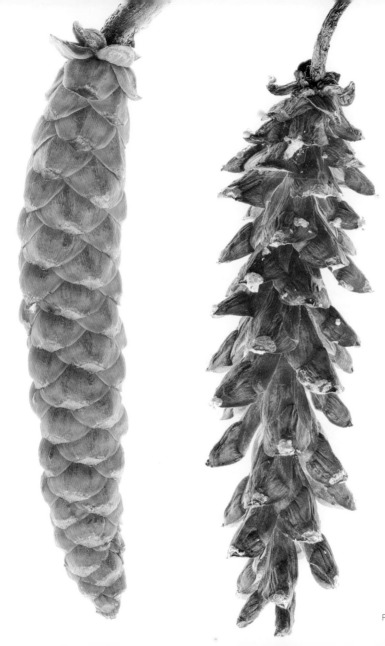

LEFT Globs of white resin make the scales of mature white pine (*Pinus strobus*) cones look as though they've been frosted.

FAR LEFT When only a year old, the female cone of the white pine is a study in metallic greens and browns.

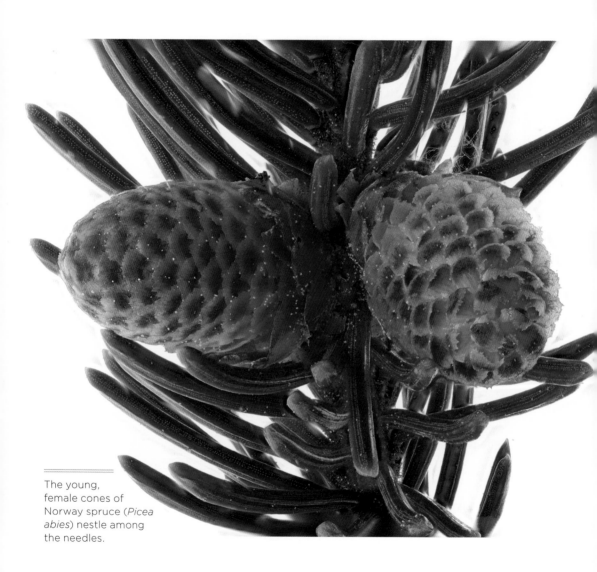

The young, female cones of Norway spruce (*Picea abies*) nestle among the needles.

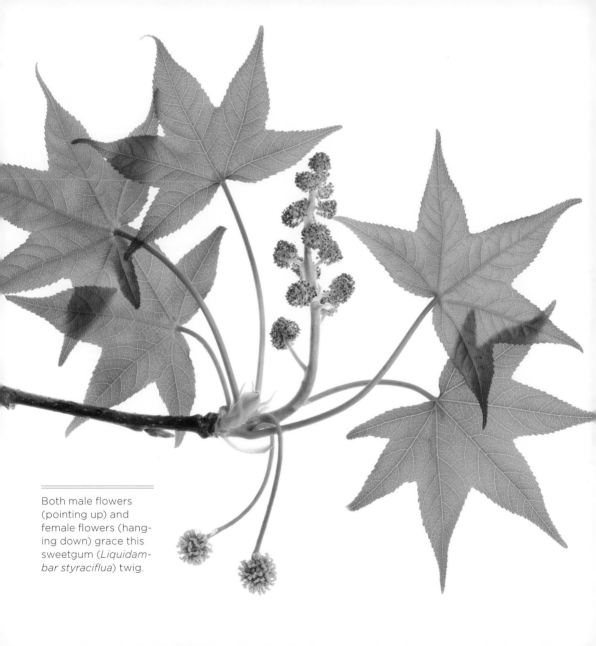

Both male flowers (pointing up) and female flowers (hanging down) grace this sweetgum (*Liquidambar styraciflua*) twig.

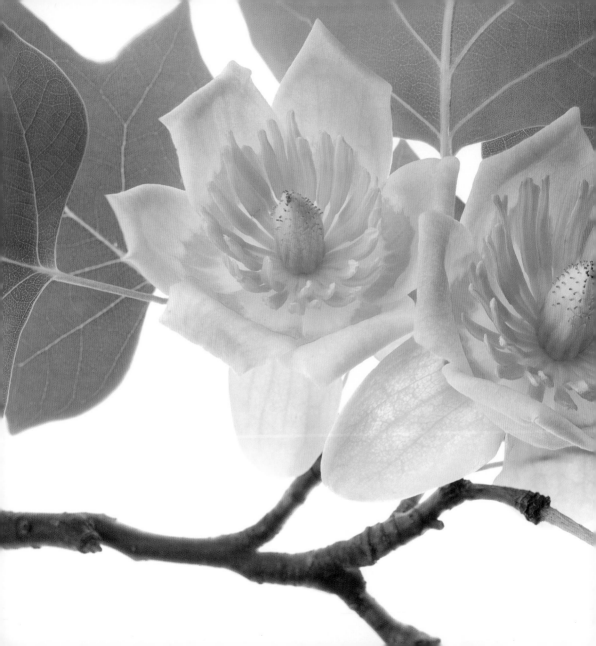

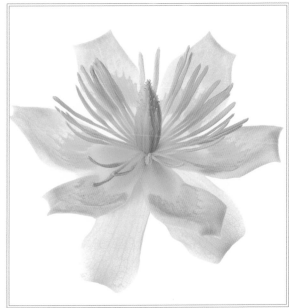

There are strap-like stamens and a greenish column of pistils in the center of the tulip poplar (*Liriodendron tulipifera*) flower. The column of pistils will develop into the samaracetum, or cone.

LEFT Two showy tulip poplar flowers and the woody axis of the previous season's cone (lower right) appear on this twig.

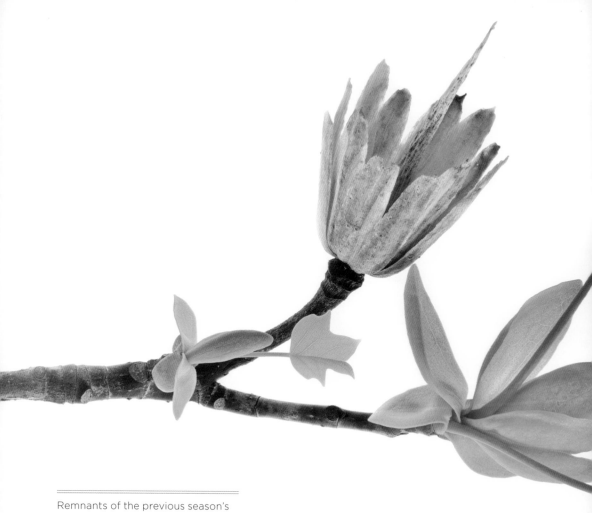

Remnants of the previous season's cone (samaracetum) often still cling to tulip poplar (*Liriodendron tulipifera*) twigs as new leaves appear.

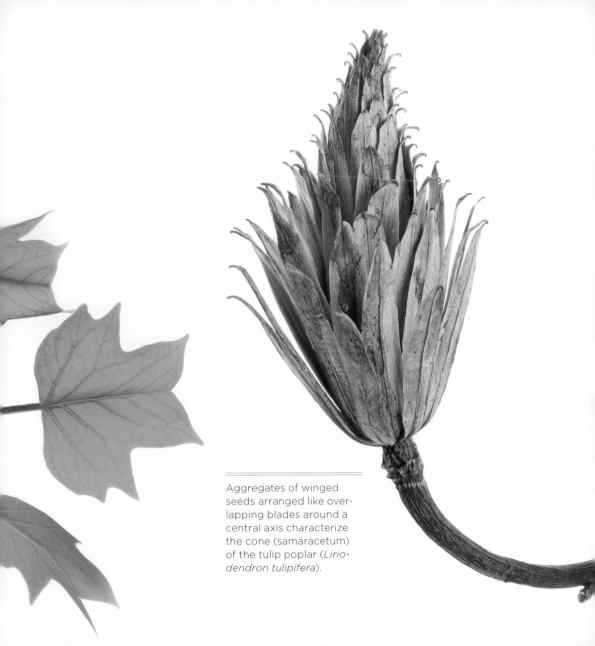

Aggregates of winged seeds arranged like overlapping blades around a central axis characterize the cone (samaracetum) of the tulip poplar (*Liriodendron tulipifera*).

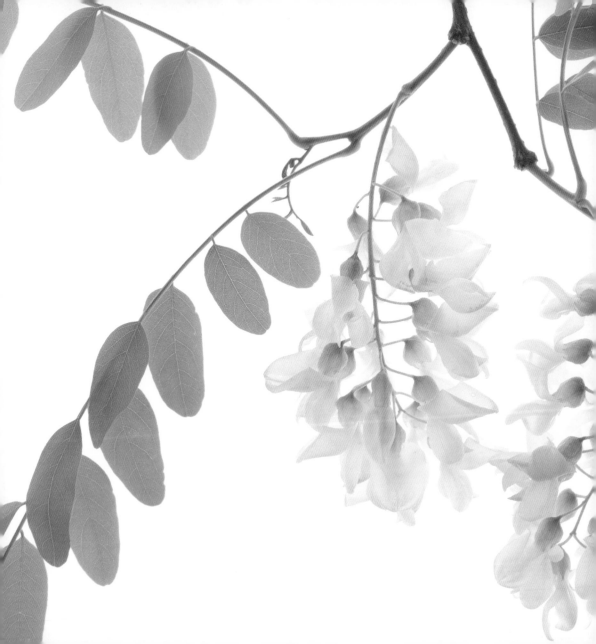

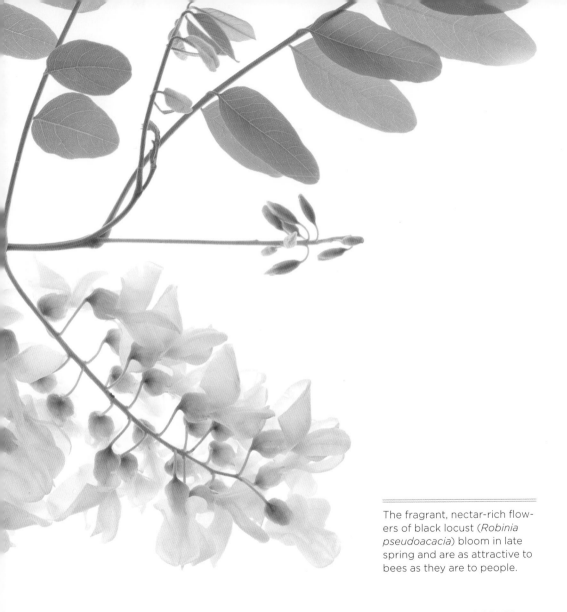

The fragrant, nectar-rich flowers of black locust (*Robinia pseudoacacia*) bloom in late spring and are as attractive to bees as they are to people.

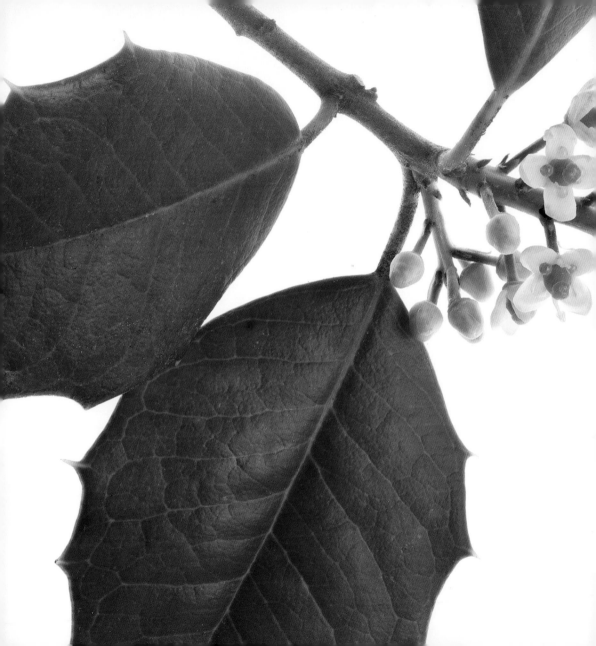

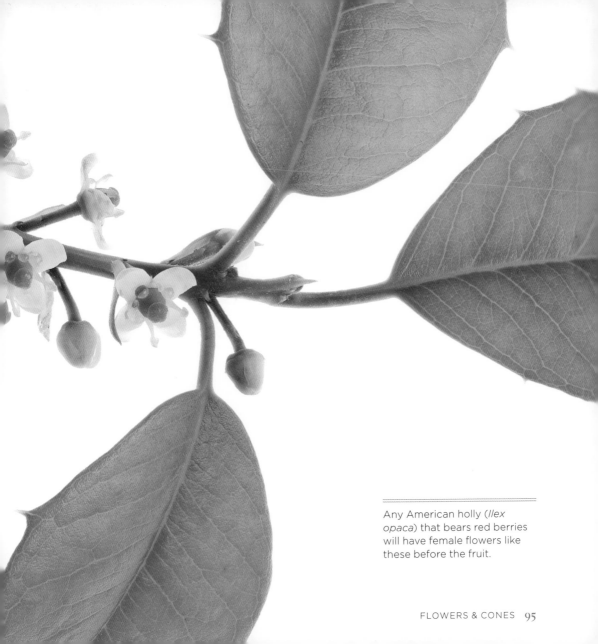

Any American holly (*Ilex opaca*) that bears red berries will have female flowers like these before the fruit.

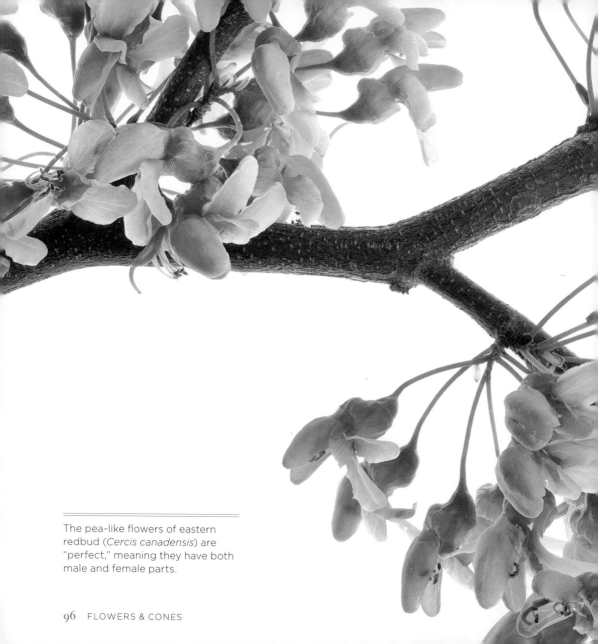

The pea-like flowers of eastern redbud (*Cercis canadensis*) are "perfect," meaning they have both male and female parts.

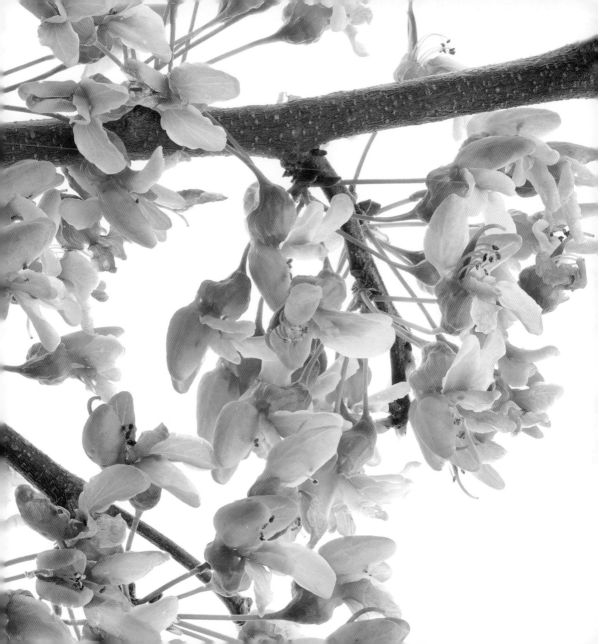

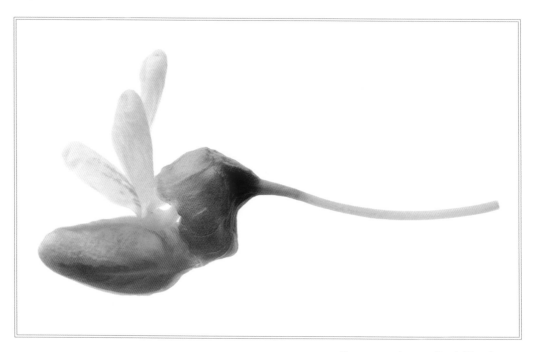

Turn an eastern redbud (*Cercis canadensis*) flower on its side, with its stalk pointing out like a beak, and it looks like a hummingbird!

RIGHT Although they emerge before the leaves, white ash (*Fraxinus americana*) flowers, like these mature ones, often go unnoticed.

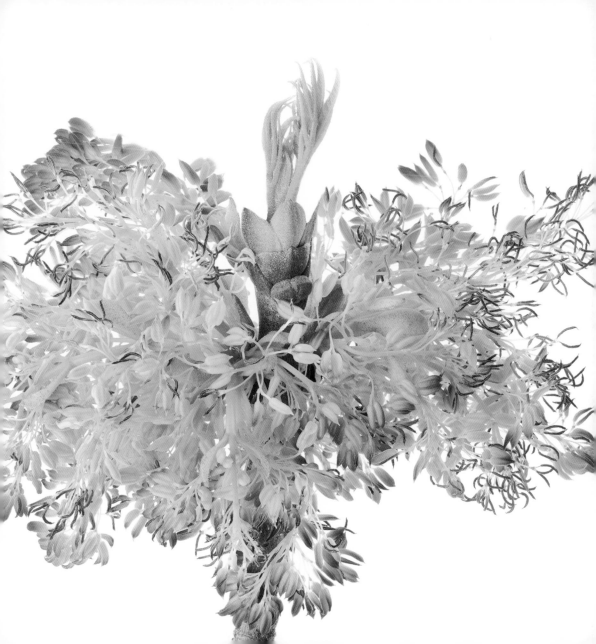

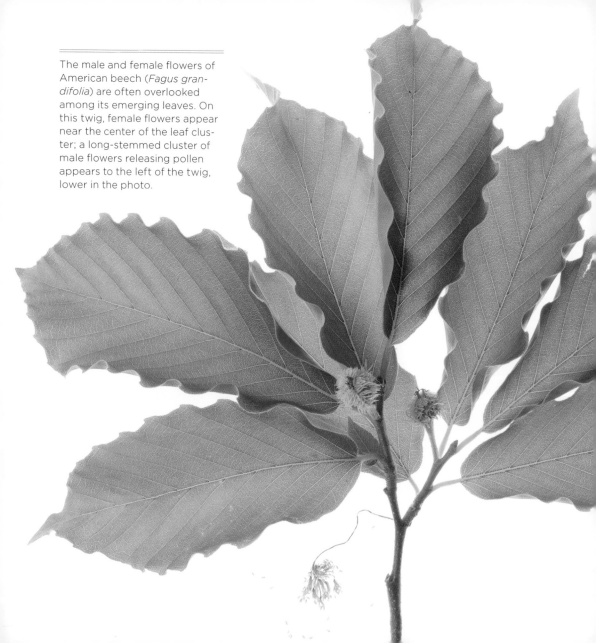

The male and female flowers of American beech (*Fagus grandifolia*) are often overlooked among its emerging leaves. On this twig, female flowers appear near the center of the leaf cluster; a long-stemmed cluster of male flowers releasing pollen appears to the left of the twig, lower in the photo.

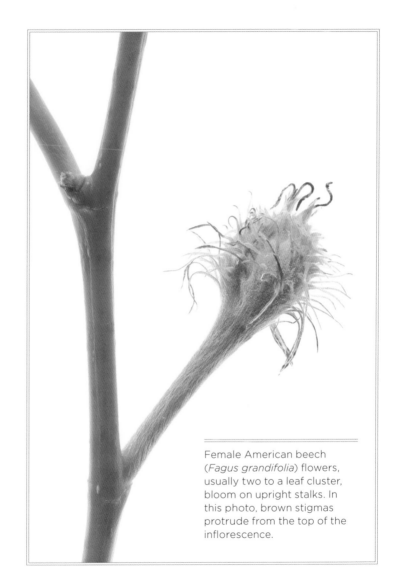

Female American beech (*Fagus grandifolia*) flowers, usually two to a leaf cluster, bloom on upright stalks. In this photo, brown stigmas protrude from the top of the inflorescence.

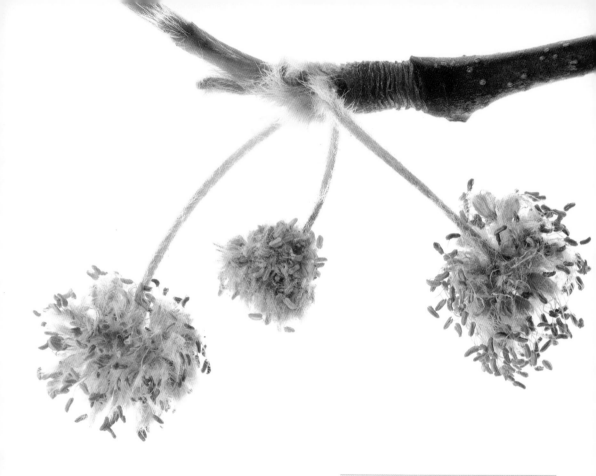

ABOVE Clusters of male flowers dangle from an American beech (*Fagus grandifolia*) twig.

RIGHT Male and female sassafras (*Sassafras albidum*) flowers usually bloom on separate trees. These are female.

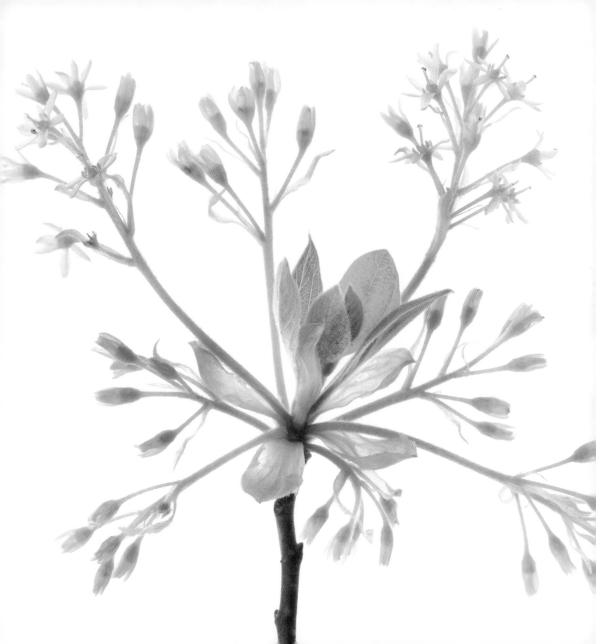

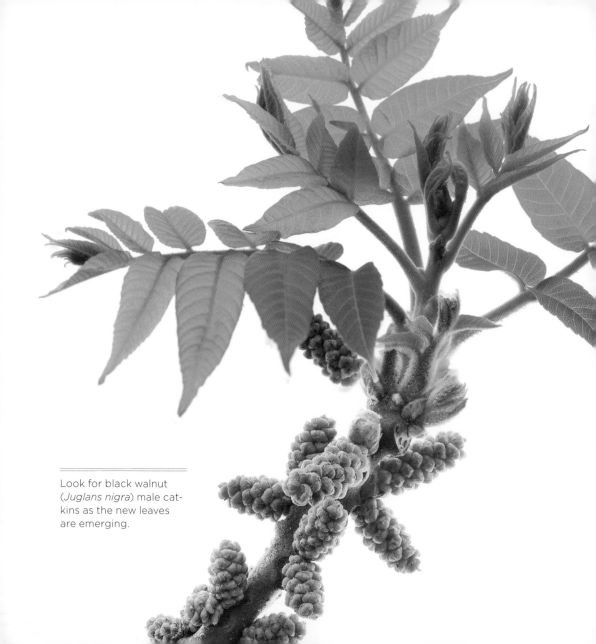

Look for black walnut (*Juglans nigra*) male catkins as the new leaves are emerging.

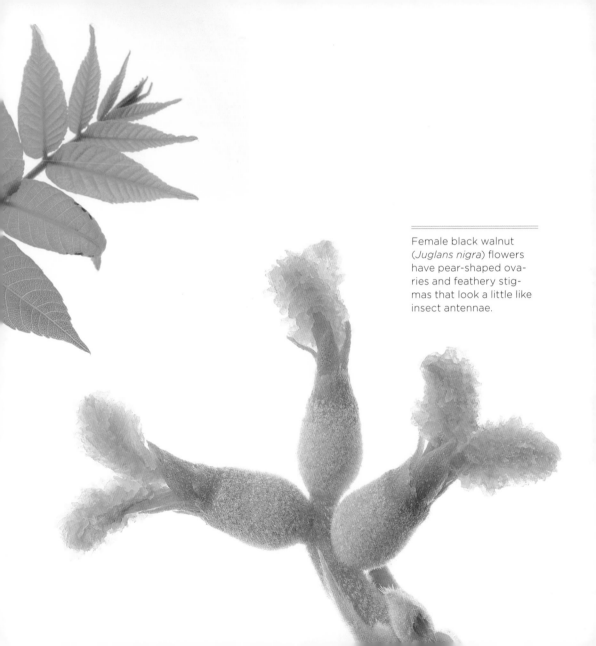

Female black walnut (*Juglans nigra*) flowers have pear-shaped ovaries and feathery stigmas that look a little like insect antennae.

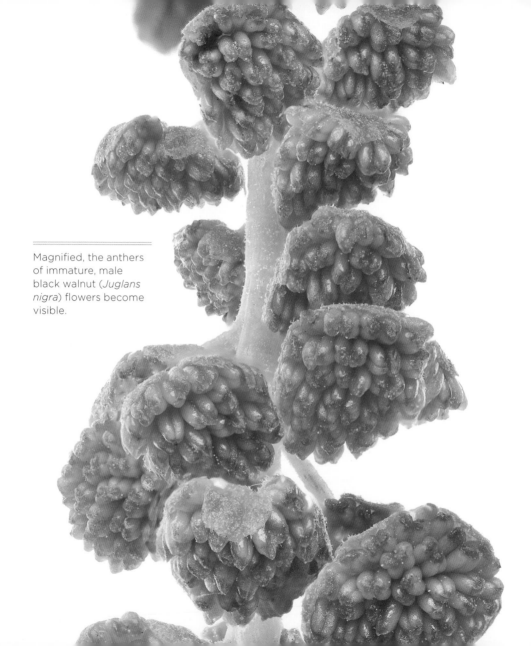

Magnified, the anthers of immature, male black walnut (*Juglans nigra*) flowers become visible.

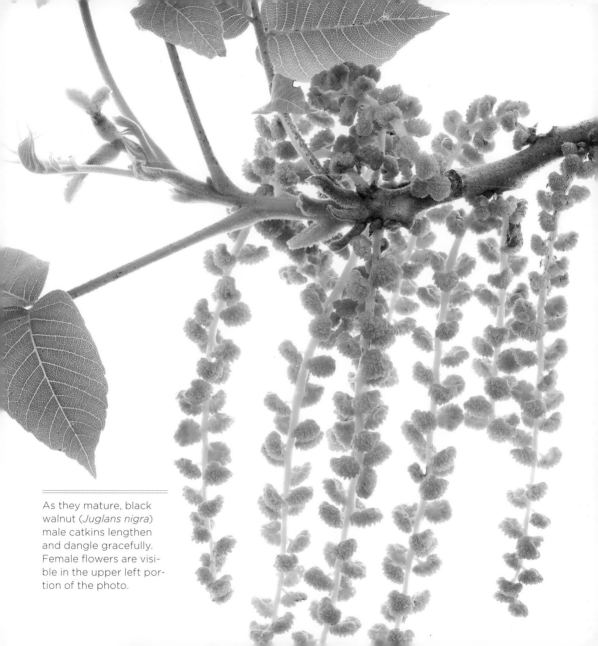

As they mature, black walnut (*Juglans nigra*) male catkins lengthen and dangle gracefully. Female flowers are visible in the upper left portion of the photo.

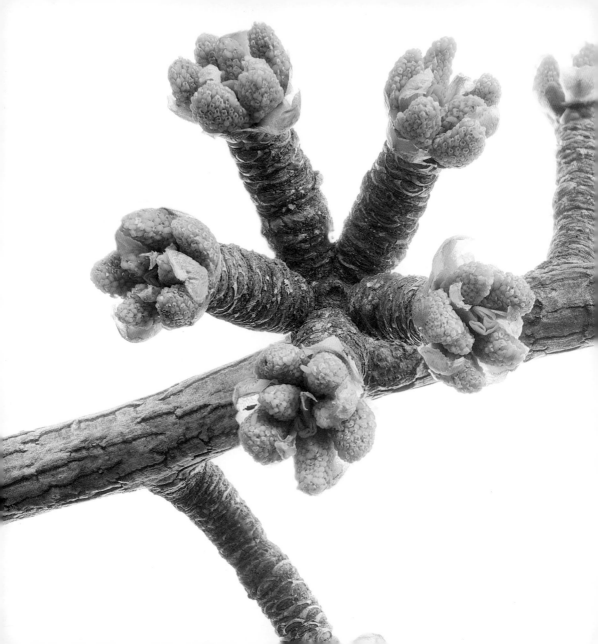

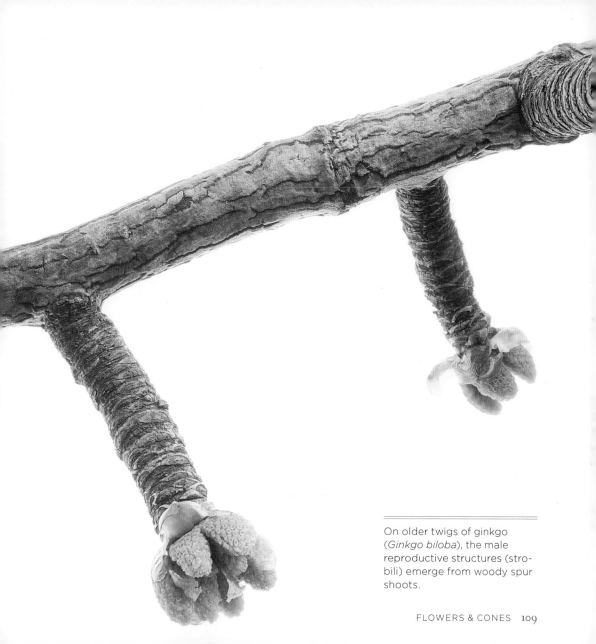

On older twigs of ginkgo
(*Ginkgo biloba*), the male
reproductive structures (stro-
bili) emerge from woody spur
shoots.

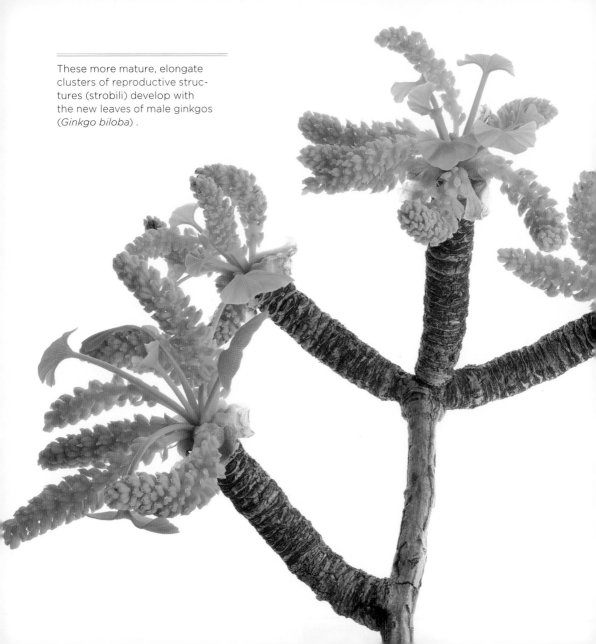

These more mature, elongate clusters of reproductive struc- tures (strobili) develop with the new leaves of male ginkgos (*Ginkgo biloba*).

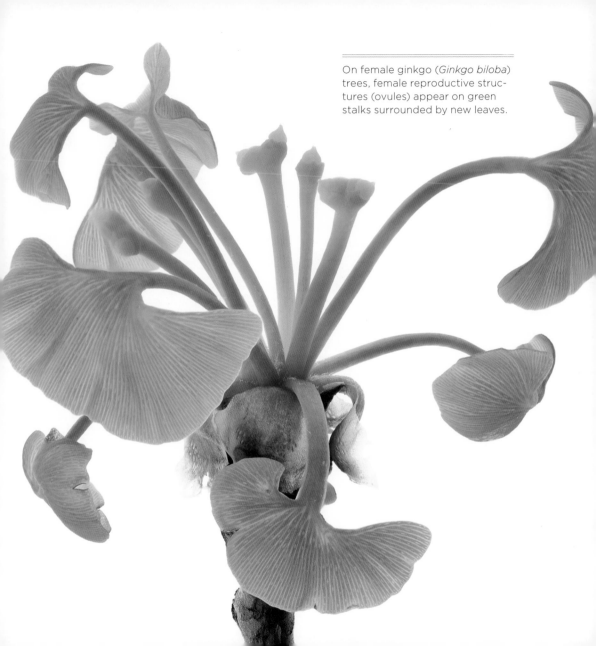

On female ginkgo (*Ginkgo biloba*) trees, female reproductive structures (ovules) appear on green stalks surrounded by new leaves.

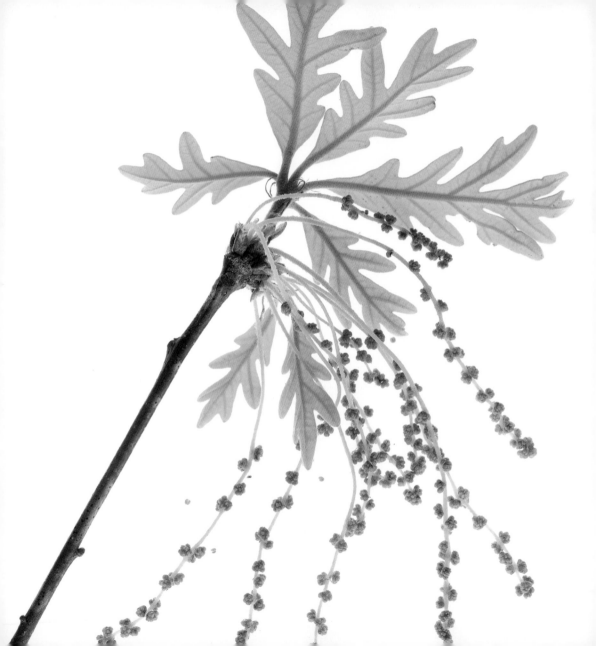

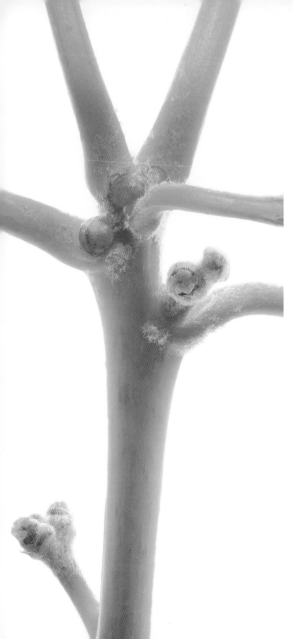

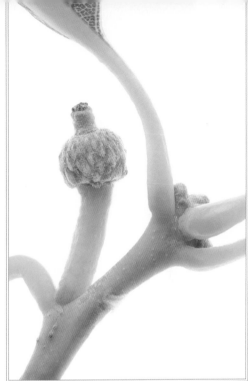

As white oak (*Quercus alba*) flowers mature, you will begin to see rings of bracts reminiscent of the acorn cup scales they will become.

LEFT This close-up shows female white oak flowers emerging from the axils of new leaves.

FAR LEFT Male white oak flowers dangle in tassel-like catkins.

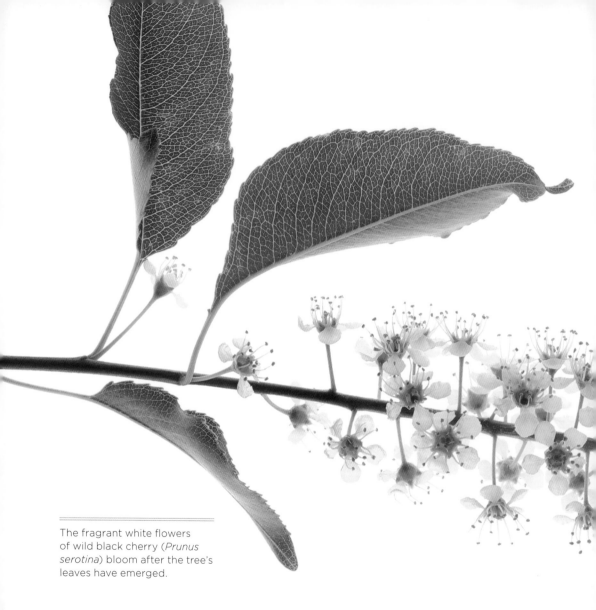

The fragrant white flowers of wild black cherry (*Prunus serotina*) bloom after the tree's leaves have emerged.

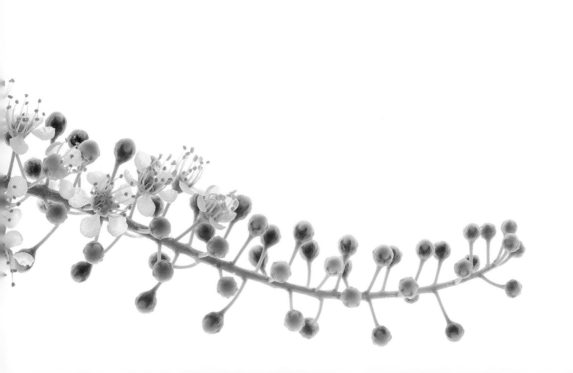

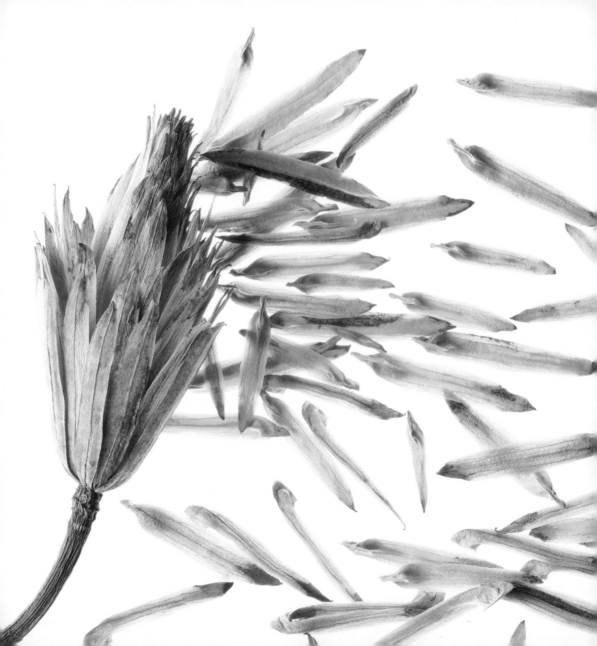

FRUIT & SEEDS

WHEN MOST OF US THINK OF FRUIT, WE THINK of the kinds of things we slice or scatter atop our breakfast cereals. Tree fruits do include many pulpy, edible fruits (think apple, persimmon, cherry, mulberry), but tree fruits also include the hard nut of the hickory, the pea-like pod of the mimosa, the gumball, and the maple's "helicopters." There is tremendous variety in tree fruits because the category includes every seed-enclosing structure produced by a flowering tree. Some botanists even refer to pine cones as tree fruits, but most reserve the term "fruit" for the seed structures of flowering plants, which excludes conifers.

Tree fruits are sometimes hard to write about because the technical terms describing them are often quite different from the common names we

Wind disperses the winged, single-seeded fruits of tulip poplar (*Liriodendron tulipifera*).

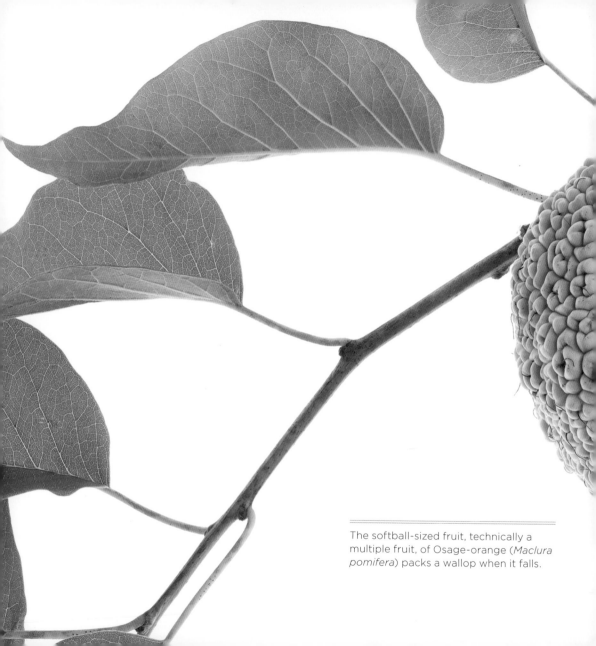

The softball-sized fruit, technically a multiple fruit, of Osage-orange (*Maclura pomifera*) packs a wallop when it falls.

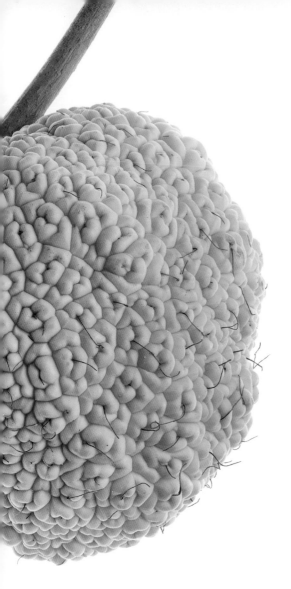

apply to them. To describe tree fruits accurately, botanists use words like pome, drupe, follicle, capsule, samara, strobile, and achene, and writers who don't want to use technical terms often have to resort to cumbersome phrases like, say, "cone-like fruiting body" and "berry-like fruit" to refer to seed structures that look like cones when they are technically woody strobiles (alder) or look like berries when they are technically fleshy cones (eastern red cedar). Fortunately for the casual observer, it is possible to become a more accurate observer of tree fruit without learning new technical terms, but the complexity of the language describing them reflects the complexity of these seed structures themselves. The fruit of the common mulberry, for example, is actually a cluster of many small drupes, each a fleshy fruit containing a single small seed; and the fruit of the American sycamore—the sycamore ball—is a collection of dry, hairy, one-seeded fruits called achenes.

Some tree fruits are fleshy, and some are dry (no flesh or pulp). Some appear singly, others in clusters. Some have protective coverings that look like leaves, such as the clustered fruits of ironwood; others have spines, like chestnut and beech; and still others have coverings that range from the thin, bladder-like bags of goldenrain tree to the thick husks of walnut. In size, fruits of common North American trees can range from small and nearly weightless (like the wafer-like fruits of

elm) to softball-sized and over a pound (such as the Osage-orange).

If you think of tree fruits as seed delivery systems, their diversity will seem even more remarkable. There is clearly more than one way to deliver a seed to a place where it might successfully germinate. Just as human beings have invented brown trucks and bubble wrap to help deliver packages safely, trees have developed seed structures to accomplish safe delivery of seeds. Their structures are designed to help move the seeds to auspicious locations for germination, keep them alive as they travel, protect them from predation by animals, prevent them from germinating at the wrong time or in the wrong spot, and supply them with enough energy to keep them alive until they can develop succoring roots. Assign the problem of accomplishing all that to a thousand species of North American trees (a hundred thousand species worldwide), give them millions of years to work on it, and you have the incredible range of tree fruits we observe today.

Prickly husks—a deterrent, one presumes, to some four-legged animals—are just one of many strategies trees have developed to protect their seeds from predation. Predator satiation is another. This term relates to the "mast years," or boom years, we witness when trees, particularly oaks, produce a significant abundance of fruit. In such years, trees produce more fruit than their predators can eat, thereby assuring that some of the

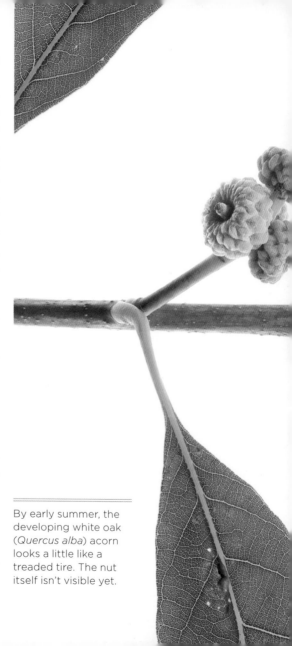

By early summer, the developing white oak (*Quercus alba*) acorn looks a little like a treaded tire. The nut itself isn't visible yet.

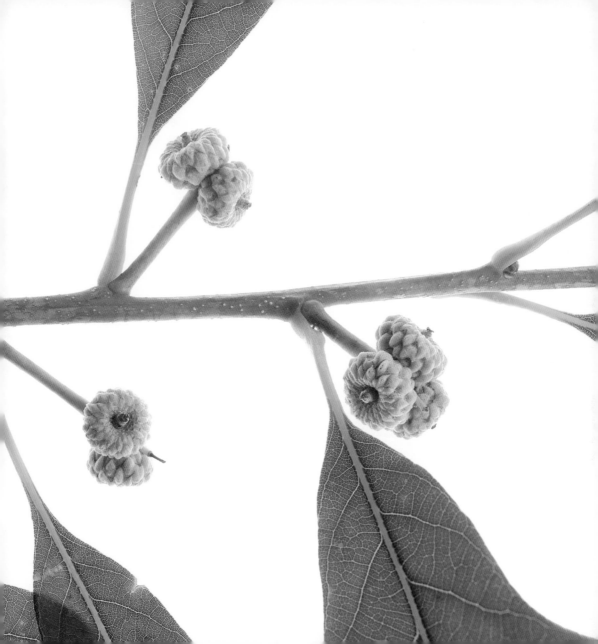

seeds escape predation. Bust years of seed production, which typically follow a mast year, further ensure seed survival by keeping predator populations low. Food scarcity reduces predator populations, so there are fewer predators around in subsequent years to feed on available seeds.

Questions to consider when looking at a tree fruit: What does it look like? When does it mature? How does it travel? When and under what conditions do its seeds germinate? Some tree fruits mature in spring (elm, willow), some in summer (cherries, mulberries, some maples), and most in fall (oak, chestnut, persimmon, tulip poplar). Tree seeds are dispersed by wind, water, propulsion, gravity, man, and other animals. Light seeds, like the whirligigs of ash and maple, ride the wind. The witch hazel propels its seeds, bullet-like, into the air. Gravity acts on all seeds to bring them to the ground, but gravity really exerts itself on big fruits like Osage-oranges, which roll like bowling balls away from a parent tree on a slope. Willow seeds often ride the wind, then travel by water to the riparian areas in which they are most likely to germinate. ❖

Often hidden under heart-shaped leaves are the graceful, immature seed pods of eastern redbud (*Cercis canadensis*).

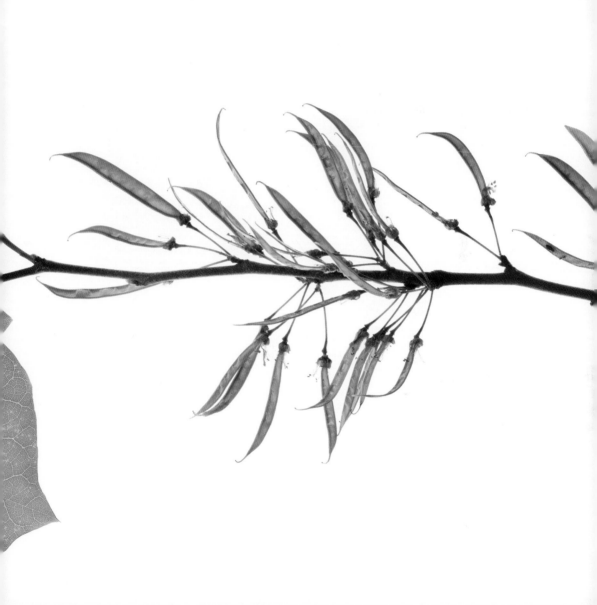

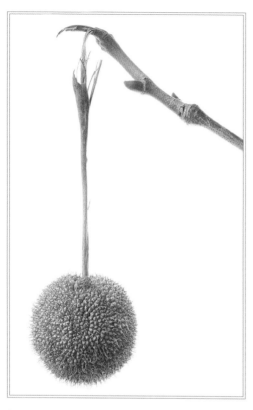

An American sycamore (*Platanus occidentalis*) ball dangles from a winter twig.

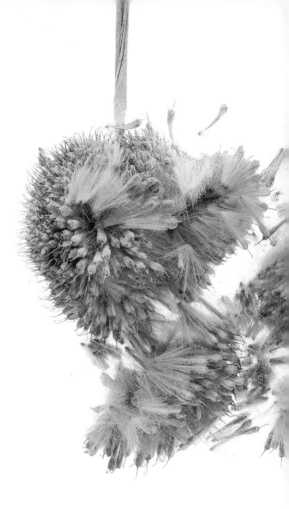

RIGHT American sycamore balls, made up of tightly aggregated seeds (achenes), usually remain on the tree over the winter and break up the following spring, dispersing their seeds.

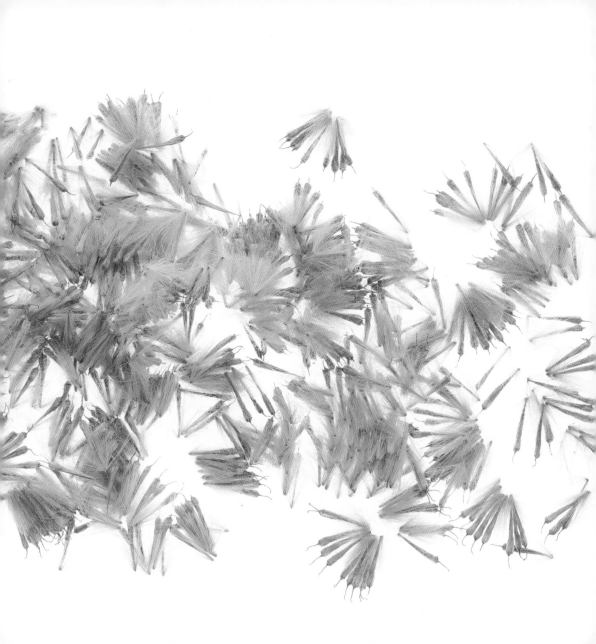

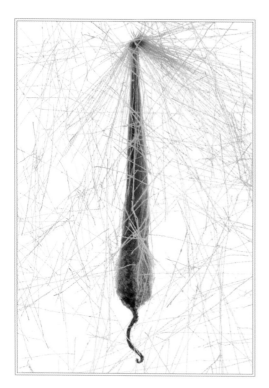

In this close-up, an American sycamore (*Platanus occidentalis*) seed (achene) is surrounded by some of the fine hairs that help it ride the wind.

RIGHT Following seed dispersal, the cores of American sycamore balls look like mini moon-scapes. As their coverings degrade, the many thread-like filaments inside the stems also become visible.

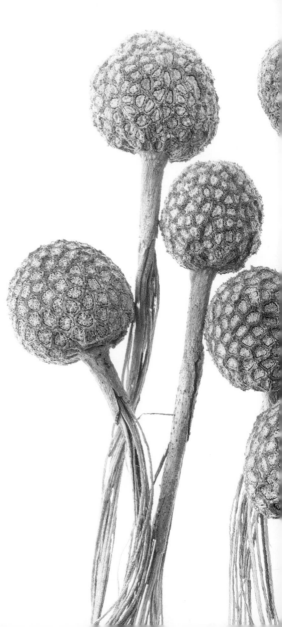

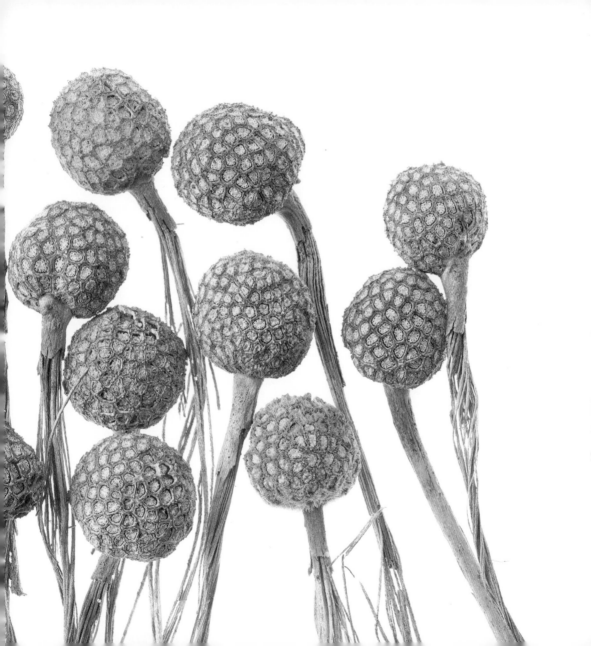

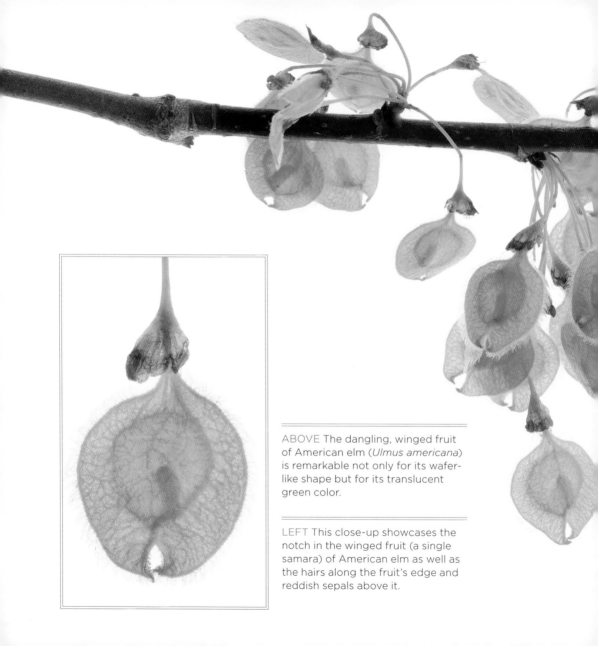

ABOVE The dangling, winged fruit of American elm (*Ulmus americana*) is remarkable not only for its wafer-like shape but for its translucent green color.

LEFT This close-up showcases the notch in the winged fruit (a single samara) of American elm as well as the hairs along the fruit's edge and reddish sepals above it.

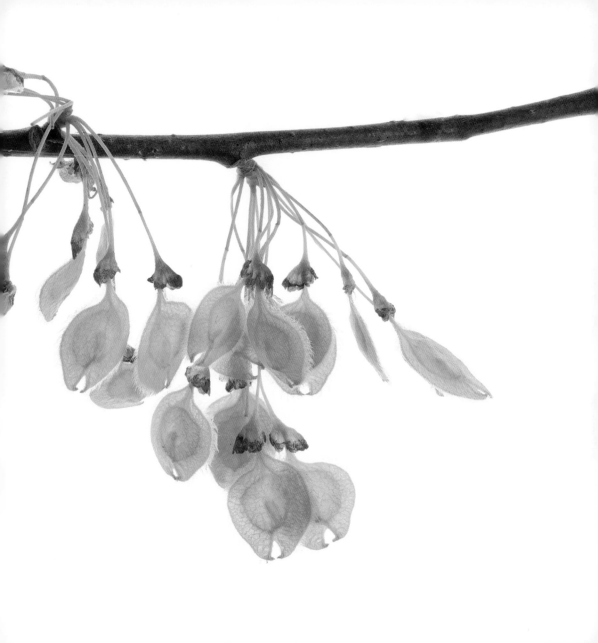

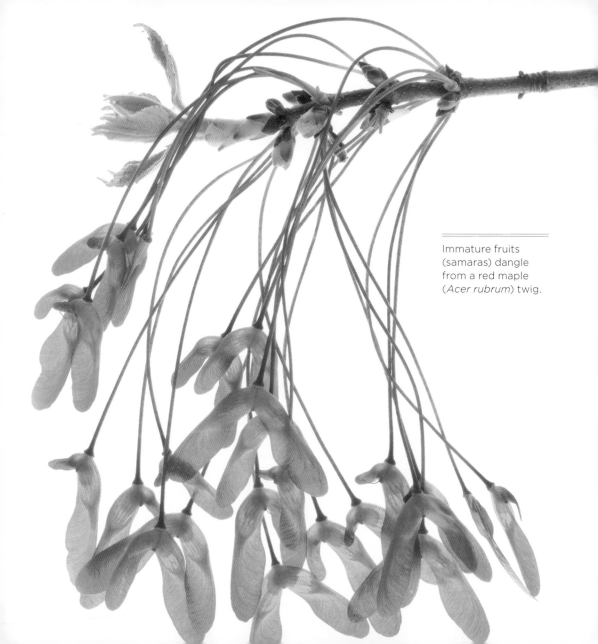

Immature fruits
(samaras) dangle
from a red maple
(*Acer rubrum*) twig.

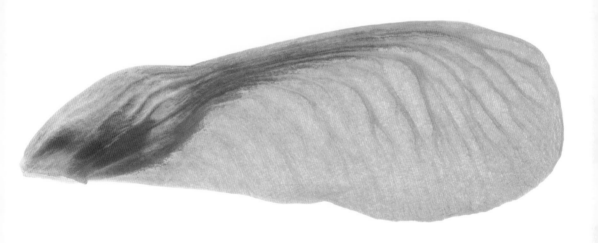

Although the only true embryo in this winged red maple (*Acer rubrum*) seed (half of its two-winged samara) resides in the seed itself, the entire structure looks embryonic when viewed this close.

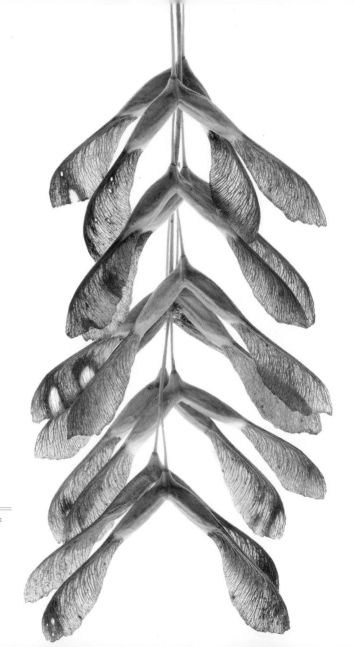

Winged fruits (samaras) of boxelder (*Acer negundo*) hang in long, narrow clusters and often persist into the winter.

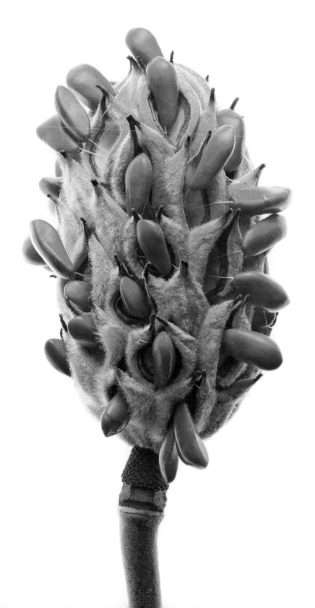

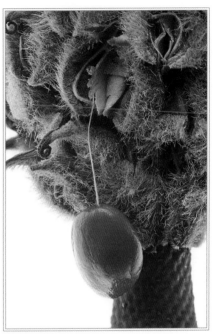

Hanging from a stretchy thread, the southern magnolia (*Magnolia grandiflora*) seed dangles and sways in the wind, effectively offering itself to birds and small mammals.

LEFT Southern magnolia seeds are released from the tree's cones on taffy-like threads.

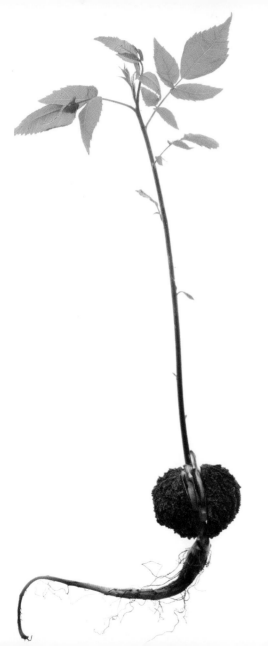

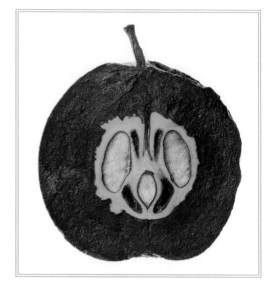

In cross section, black walnut (*Juglans nigra*) nut meats are visible inside their shell, which is surrounded by the fruit's dark husk.

LEFT Gardeners removing black walnut seedlings from their gardens occasionally find a nut still attached to the roots.

RIGHT These views of black walnut illustrate emerging leaves and a pair of female flowers (top left), the developing fruit with female stigmas still attached, (top right) and the maturing fruit (bottom).

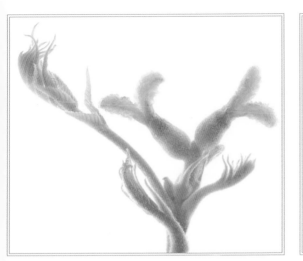

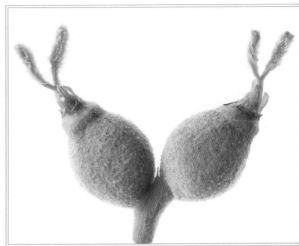

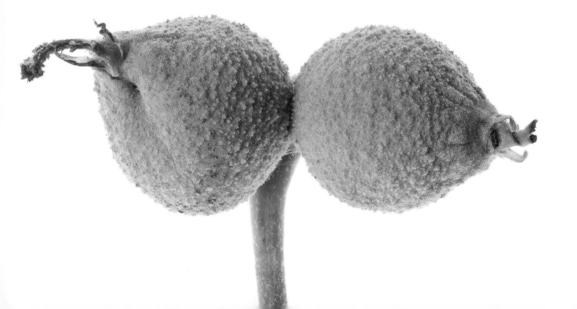

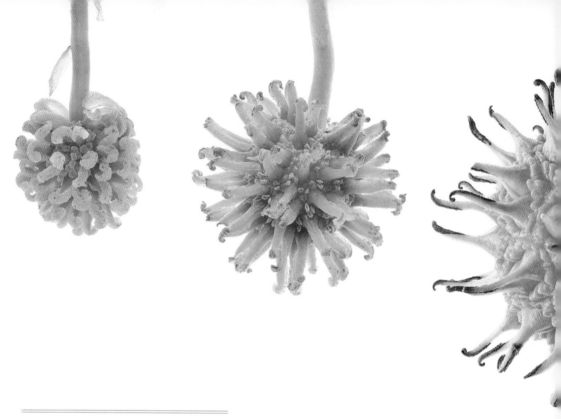

The familiar gumball of sweetgum
(*Liquidambar styraciflua*) develops
(left to right) from female flower to
maturity in about seven months. Think
of the multichambered gumball not as a
nuisance but as a masterfully engineered
multiple fruit: each chamber of this spiky
contraption holds two tiny winged seeds.

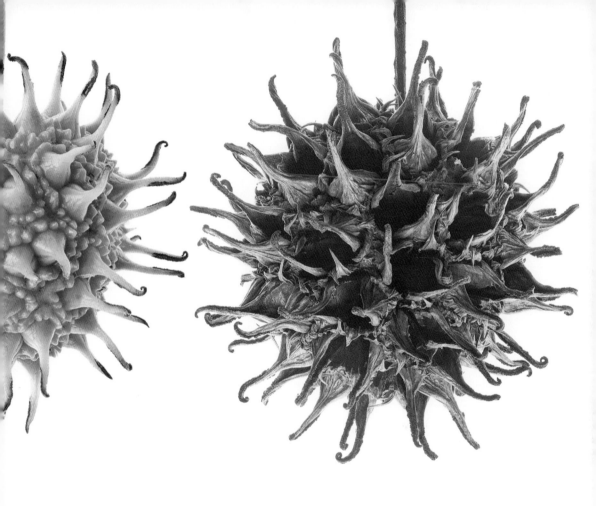

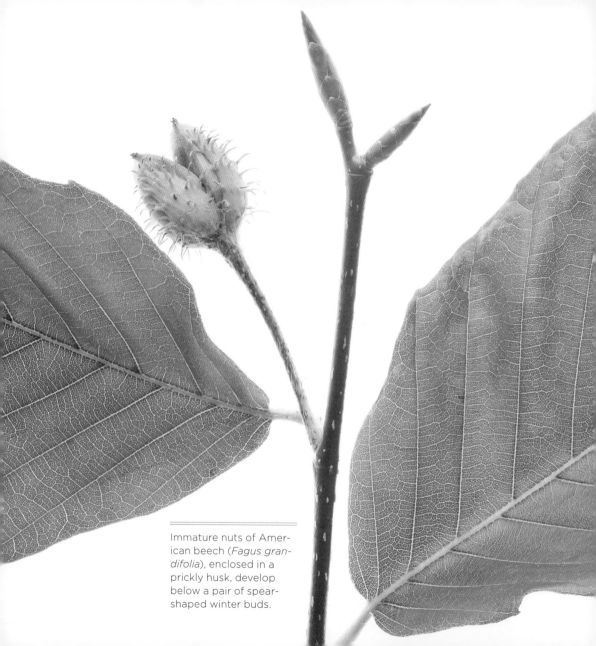

Immature nuts of American beech (*Fagus grandifolia*), enclosed in a prickly husk, develop below a pair of spear-shaped winter buds.

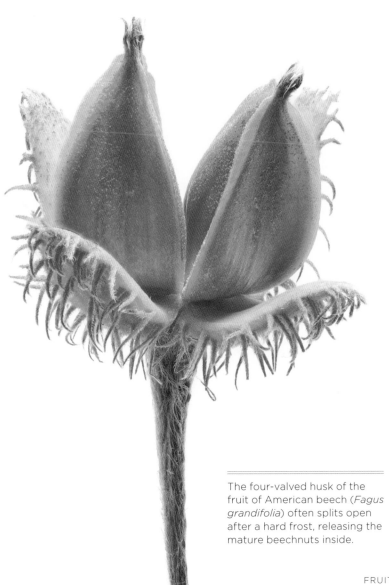

The four-valved husk of the fruit of American beech (*Fagus grandifolia*) often splits open after a hard frost, releasing the mature beechnuts inside.

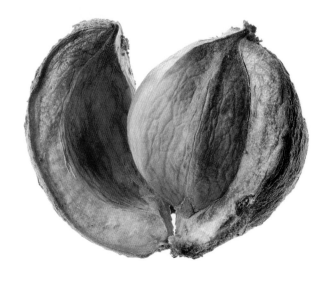

Hickory (*Carya* species) nuts reside inside a hard shell and a four-valved husk (two valves of which have been removed for this photo).

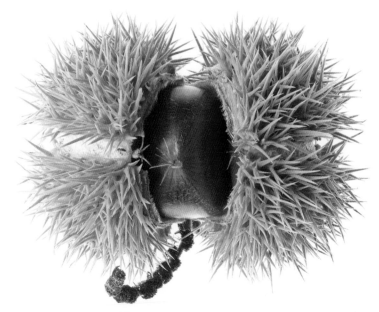

The nut of the Chinese chestnut (*Castanea mollissima*) is as smooth as its bur is prickly.

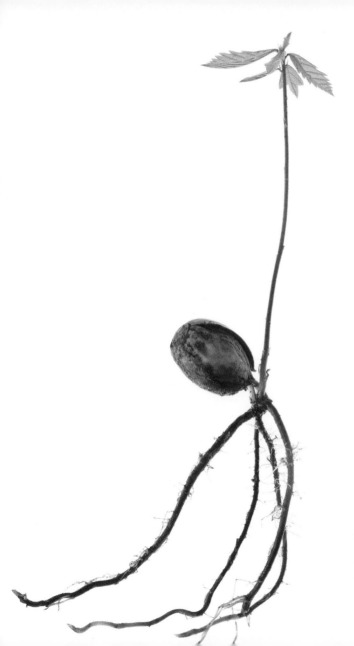

The oak sprouting from
this acorn is a chestnut
oak (*Quercus montana*).

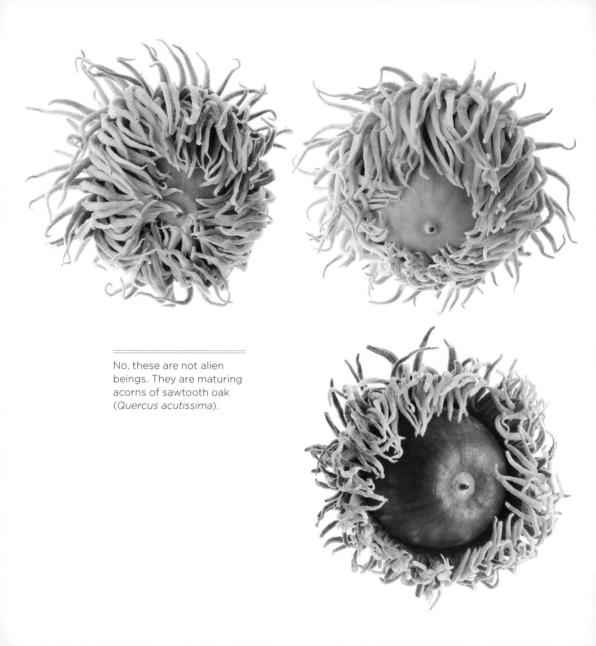

No, these are not alien beings. They are maturing acorns of sawtooth oak (*Quercus acutissima*).

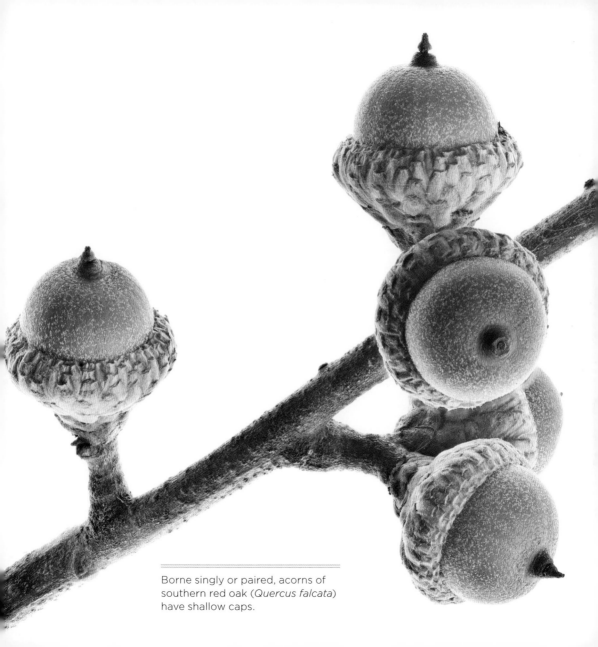

Borne singly or paired, acorns of southern red oak (*Quercus falcata*) have shallow caps.

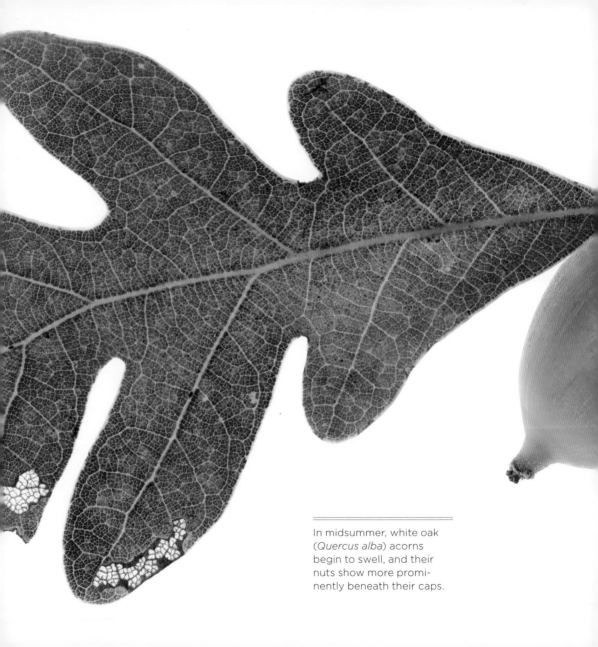

In midsummer, white oak (*Quercus alba*) acorns begin to swell, and their nuts show more prominently beneath their caps.

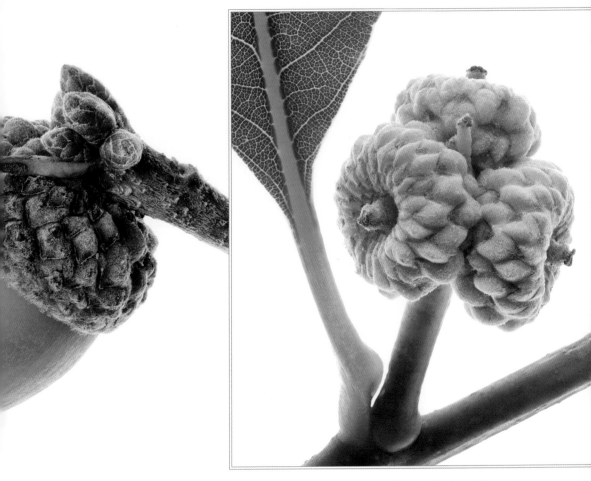

Covered with pale green scales, the developing white oak (*Quercus alba*) acorn has a remnant of the flower's style in the middle.

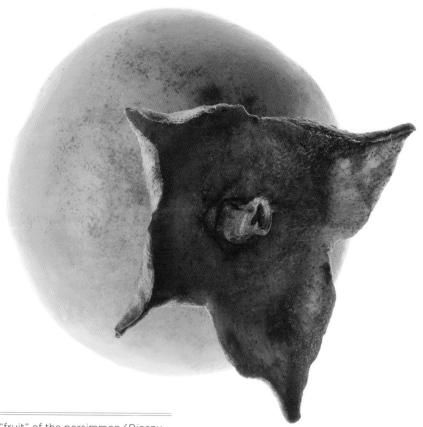

The globular "fruit" of the persimmon (*Diospyros virginiana*) is technically a berry.

RIGHT Persimmon fruit is charismatic in all its stages. Here, the immature fruit of the persimmon still has tiny black stigmas protruding from the top of the fruit; its prominent green calyx clasps the fruit below.

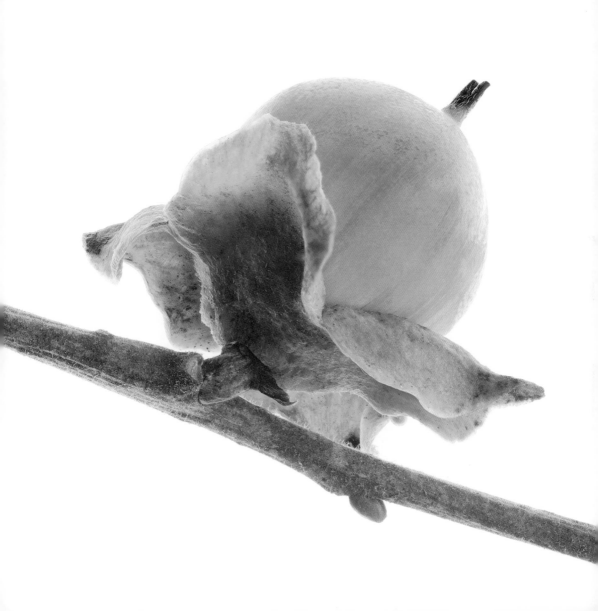

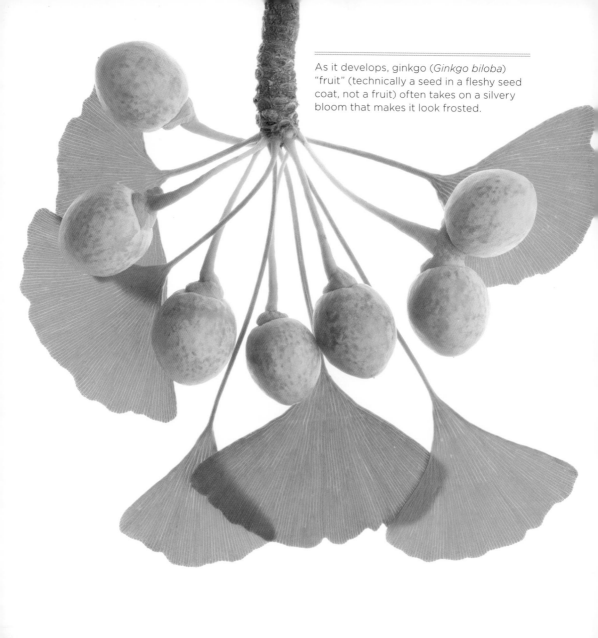

As it develops, ginkgo (*Ginkgo biloba*) "fruit" (technically a seed in a fleshy seed coat, not a fruit) often takes on a silvery bloom that makes it look frosted.

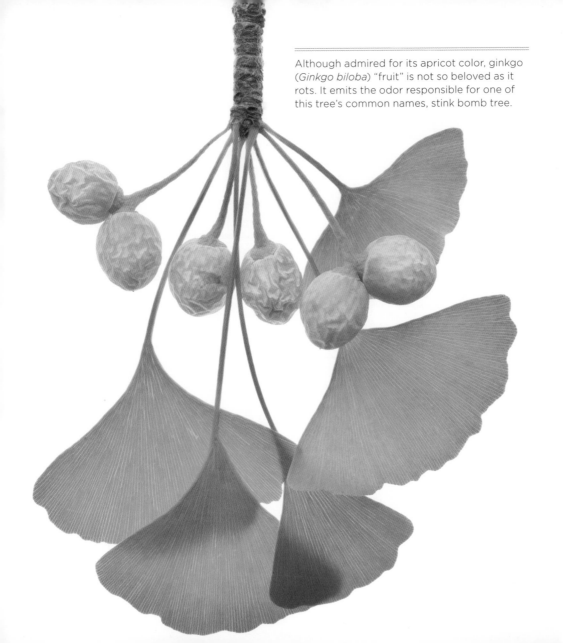

Although admired for its apricot color, ginkgo (*Ginkgo biloba*) "fruit" is not so beloved as it rots. It emits the odor responsible for one of this tree's common names, stink bomb tree.

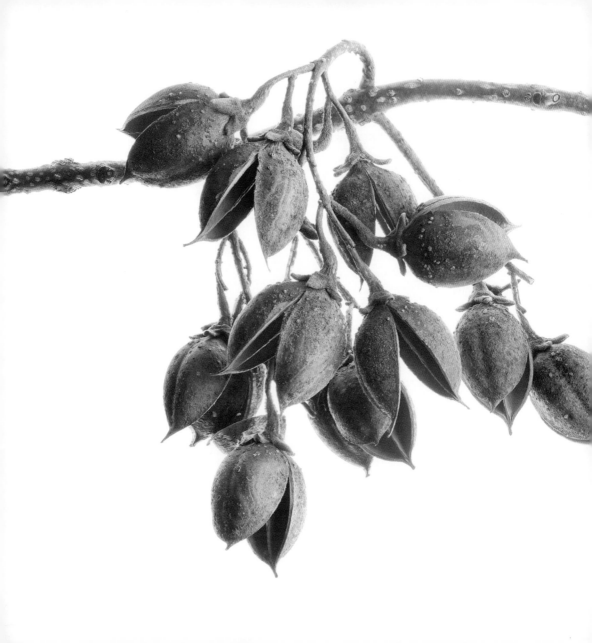

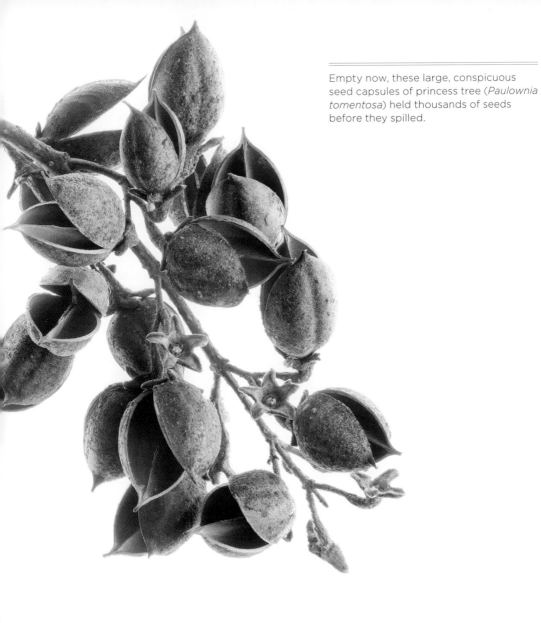

Empty now, these large, conspicuous seed capsules of princess tree (*Paulownia tomentosa*) held thousands of seeds before they spilled.

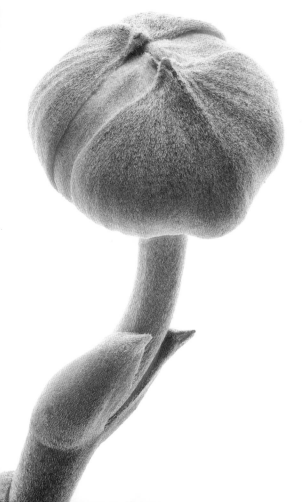

BUDS &
LEAF SCARS

WHEN MOST OF US THINK OF BUDS, WE THINK of spring phenomena—and usually in association with garden flowers. But tree buds, which contain embryonic leaves, stems, and flowers, are usually formed the summer before they grow into the forms they take each spring, and winter is one of the best times to view them.

During the summer and fall, tree buds grow to a certain size then stop, or rest, for the winter. At that stage, these winter or resting buds, as

These three photos illustrate (left to right) the terminal bud and imbricate scales of sweetgum (*Liquidambar styraciflua*) with leaf scars below, the sticky buds of horsechestnut (*Aesculus hippocastanum*) with leaf scars below, and the clenched-fist flower bud of flowering dogwood (*Cornus florida*). The photos are not to scale.

they are called, remind us that life hasn't fled the body of a leafless tree—it's just in waiting, and the shapes of next year's leaves and flowers are already programmed into its buds. Resting buds also provide one of the best ways to identify trees in winter, because their designs are unique to each species.

Compare, for example, the terminal bud of the beech to the terminal buds of oak, horsechestnut, and tulip poplar—four of the trees easiest to identify by their resting buds. (A terminal bud occurs at the end of a tree twig, as opposed to lateral buds, which occur along the twig's sides.) The terminal bud of American beech is unmistakable: shaped like a thin spear, it is a pale, yellowish brown and covered with dry, shingle-like scales. Its tip is so sharply pointed I've always thought it could be in a *CSI* episode—"murderous botanist dipped beech bud in poison," or something like that. In addition to having a distinctive shape, beech terminal buds always occur singly, which is entirely different from the terminal buds of

RIGHT The alternate arrangement of sharp, pointed resting buds is clearly visible on this American beech (*Fagus grandifolia*) twig.

FAR RIGHT Distinctive terminal buds, lateral buds, and leaf scars provide clues to the identity of post oak (*Quercus stellata*).

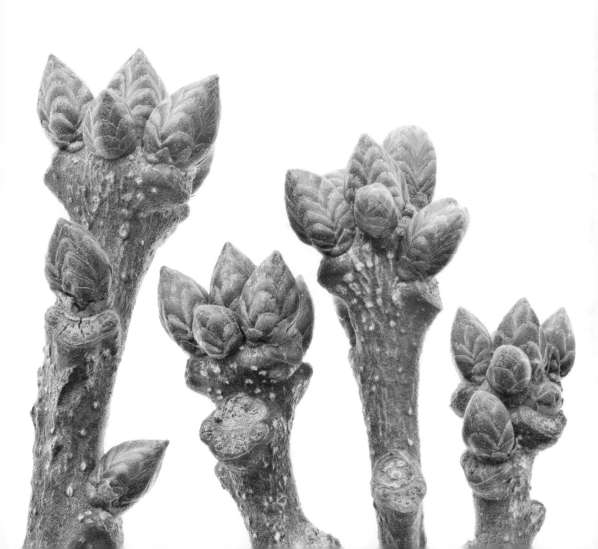

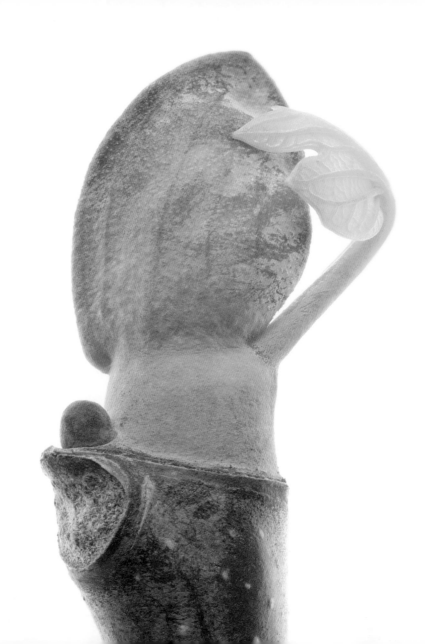

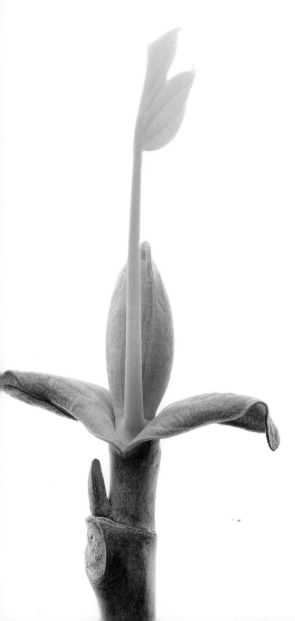

oak, for example, which occur clustered at the tips of the twigs and are coarse, stout, and hoary in comparison with the beech bud's refined, narrow, well-chiseled look.

The terminal bud of horsechestnut is large—about the size of a night-light bulb—and its scales (the protective covering of the bud) are covered with a sticky resin that makes them look and feel as if they've been dipped in molasses. The terminal bud (all resting buds, really) of tulip poplar is also relatively large, but, while actively growing, it is a study in soft, smooth, unblemished green. (Later it turns a dark, purplish brown.) The two scales (modified stipules) covering each tulip poplar bud come together like praying hands or a duck's bill, depending on your perspective. At the end of the summer, the terminal buds on a pollarded tulip poplar (one that has been cut down and then comes back with vigor) are often very

LEFT One small twig from a tulip poplar (*Liriodendron tulipifera*) illustrates (from bottom to top) a leaf scar, a stipule scar, a small brown lateral bud, brownish leaf-like stipules (curling back), a large green terminal bud, and a newly emerging leaf. Two scales (modified stipules) protect the terminal bud over winter.

FAR LEFT A nascent leaf emerges beside the terminal bud of a tulip poplar.

large, and I have had the experience of pulling them apart to discover an identifiable, folded leaf pressed against the other plant material inside. Folded down its midvein the way a valentine is often folded down the center for cutting, this embryonic leaf is minuscule but unmistakable in shape. Imagine that tiny leaf waiting patiently in those praying hands all winter, and you'll never see a leafless tulip poplar as lifeless again.

Tree buds vary in the way they are "packed" (leaves and stems, leaves and flowers, or flowers alone). In some species, it's easy to tell flower buds from leaf buds, and many trees' flower buds are rounder than their leaf buds (as in flowering dogwood). But on most trees, leaf and flower buds are indistinguishable—until their contents begins to emerge. On an oak, for example, only the lateral buds (as opposed to its terminal buds) produce flowers, but you just have to wait and see which lateral buds bloom and which unfurl leaves.

Like the leaves that follow them, buds are

RIGHT The resting buds of ginkgo (*Ginkgo biloba*) appear at the tips of woody spur shoots, together looking from a distance like thick thorns scattered along the branches.

FAR RIGHT Large flowers and graceful flower buds are among the many attractions of northern catalpa (*Catalpa speciosa*).

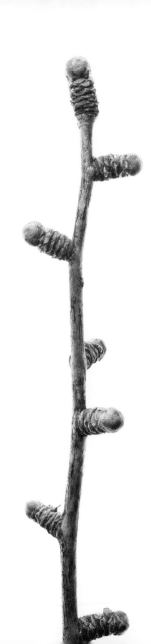

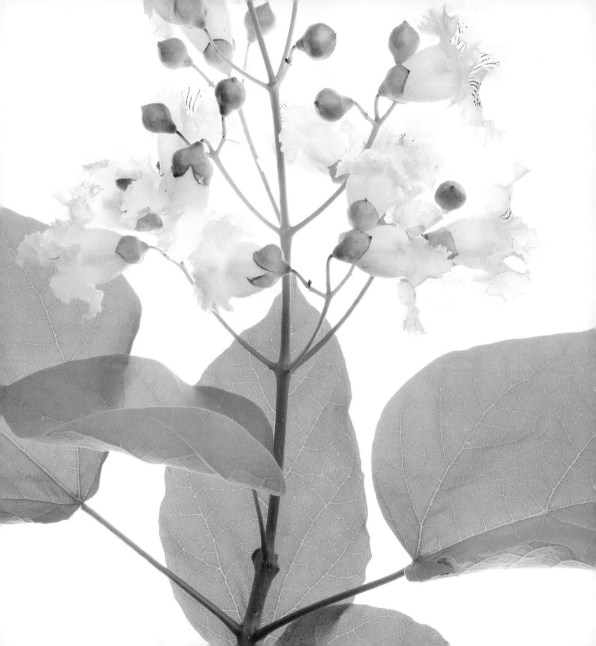

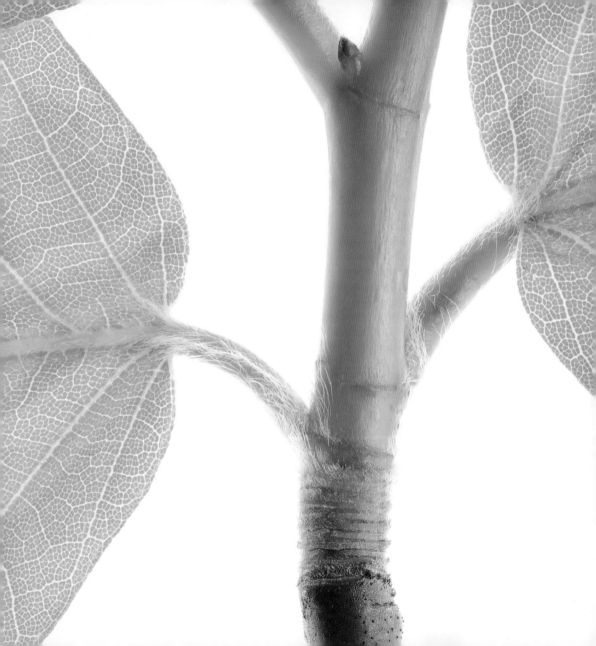

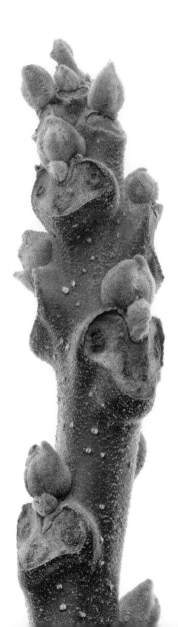

arranged in an alternate or opposite (rarely whorled) pattern along the twig, and these arrangements can help you identify trees in winter when leaves are absent. The buds of dogwood, ash, maple, princess tree, horsechestnut, and buckeye are positioned across from each other (opposite) on the stem. On most other common trees, they are alternate.

The buds of different tree species also vary in the way they are protected from drying out. Some trees have what are called naked buds (the terminal buds of the pawpaw and witch hazel, for example, are protected only by their outermost waterproof leaves), but most tree buds have protective scales covering the embryonic plant material inside. The number of scales varies from one to many, with the willow having, for example, a single cap-like scale covering its bud, the bitternut hickory (like the tulip poplar) having a pair of scales meeting but not overlapping in the middle,

LEFT Some naturalists suggest looking for faces in the shapes of leaf scars and patterns of bundle scars. Look for the shape of E.T.'s head in the leaf scars of black walnut (*Juglans nigra*). Also visible on this twig are the tree's resting buds.

FAR LEFT A band of yellowish bud scale scars, like the threads of a small screw, marks the transition from old to new growth on this American beech (*Fagus grandifolia*) twig.

and most tree species having numerous overlapping scales arranged in various patterns, like shingles on a roof.

There are all sorts of other bud characteristics that help differentiate tree species, and a good field guide or website will alert you to things like the lopsided bud of the American linden (its scales are asymmetrical), the pale wooliness of the black oak bud, the embedded bud of the black locust (sunken below the surface of the twig), and the stalked bud of the smooth alder (raised above the surface of the twig on a short stem).

The sizes, shapes, and positions of leaf scars—the areas, usually below the buds, where the previous year's leaves have fallen off—also vary among tree species and are equally useful in identifying trees in winter, not to mention being interesting for their visual variety alone. I like to think of leaf scars as tiny family crests, because many of them are shaped like crests or shields, and the markings inside them provide clues to the species' identity.

Probably the easiest leaf scar to see on a common tree is the large, heart-shaped leaf scar of tree-of-heaven. On the smooth, slightly furry

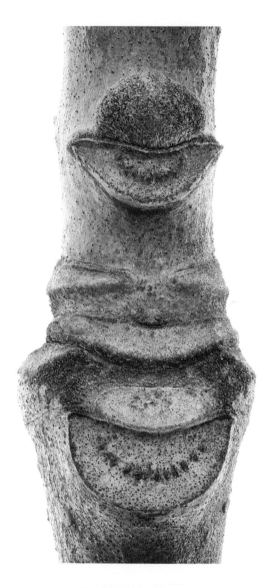

Twigs of (left to right) green ash (*Fraxinus pennsylvanica*), horsechestnut (*Aesculus hippocastanum*), and sweetgum (*Liquidambar styraciflua*) show identifying features including sizes and shapes of leaf scars and number and configuration of bundle scars.

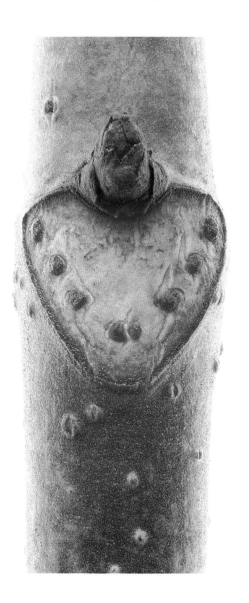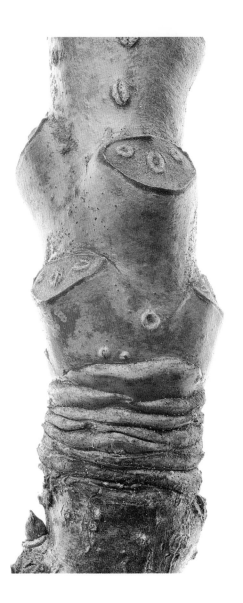

surface of tree-of-heaven, this leaf scar stands out like a scab on a knee. Other leaf scar shapes include some that are triangular in outline, some round, some oval, some scalloped, some shield-shaped, some crescent-shaped, and many other shapes, each indicative of the species. Leaf scars also vary in their relationship to the stem (raised above, depressed into, or flush with the surface of the twig), in their texture, and in the number and configuration of the bundle scars within them.

Bundle scars? If you don't know this term, it's a good one to learn. To look at a tree up close and miss its bundle scars is to overlook its leaves' broken connection to the tree (and all the back-and-forth energy and water exchange that implies). Bundle scars are the tiny, raised spots, usually looking like dots or bars, that occur inside a leaf scar and that mark the places where the leaf's "pipes" have been broken. The word "pipes" works best for me in this context, but what we are talking about is the tree's vascular tissue, or veins, through which water and nutrients pass from the tree into the leaves and through which food passes from the leaves into the tree. Trees of each species have different "pipe" arrangements, and when you look at the bundle scars in a leaf scar, what you are seeing is the pattern of broken pipes. ❖

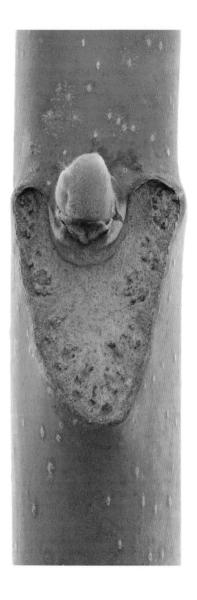

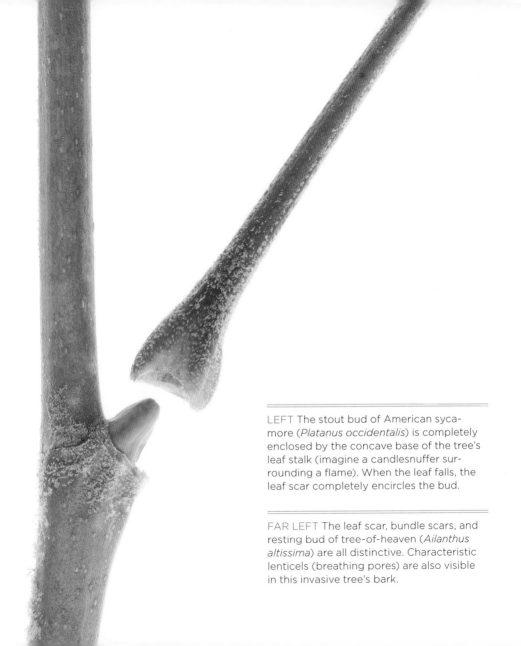

LEFT The stout bud of American syca-more (*Platanus occidentalis*) is completely enclosed by the concave base of the tree's leaf stalk (imagine a candlesnuffer sur-rounding a flame). When the leaf falls, the leaf scar completely encircles the bud.

FAR LEFT The leaf scar, bundle scars, and resting bud of tree-of-heaven (*Ailanthus altissima*) are all distinctive. Characteristic lenticels (breathing pores) are also visible in this invasive tree's bark.

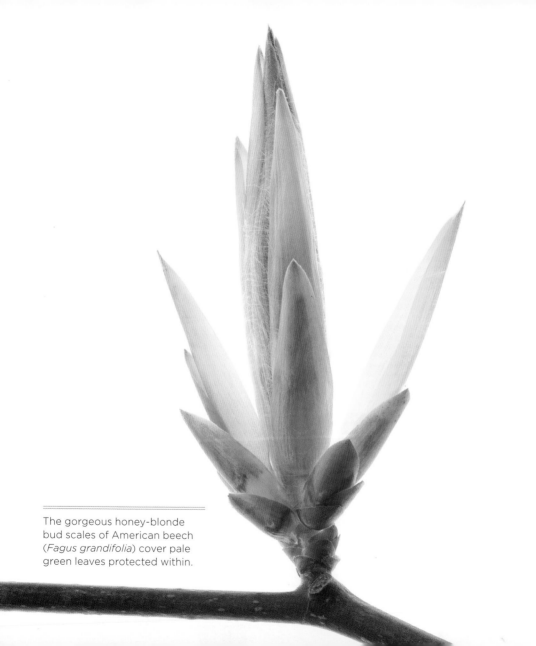

The gorgeous honey-blonde bud scales of American beech (*Fagus grandifolia*) cover pale green leaves protected within.

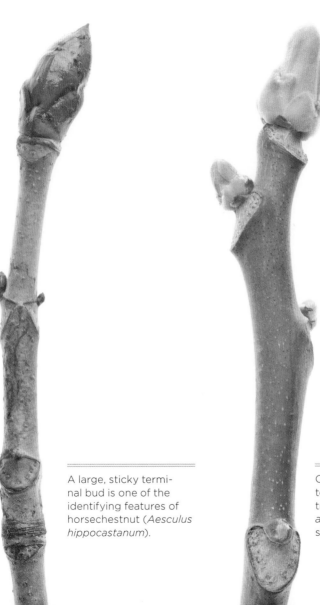

A large, sticky terminal bud is one of the identifying features of horsechestnut (*Aesculus hippocastanum*).

One of the easiest trees to identify without leaves, tree-of-heaven (*Ailanthus altissima*) has large, heart-shaped leaf scars.

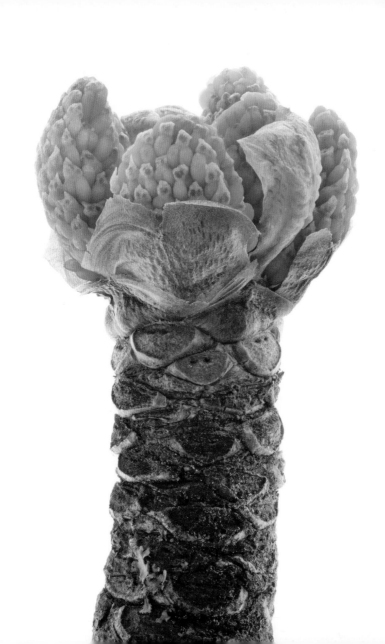

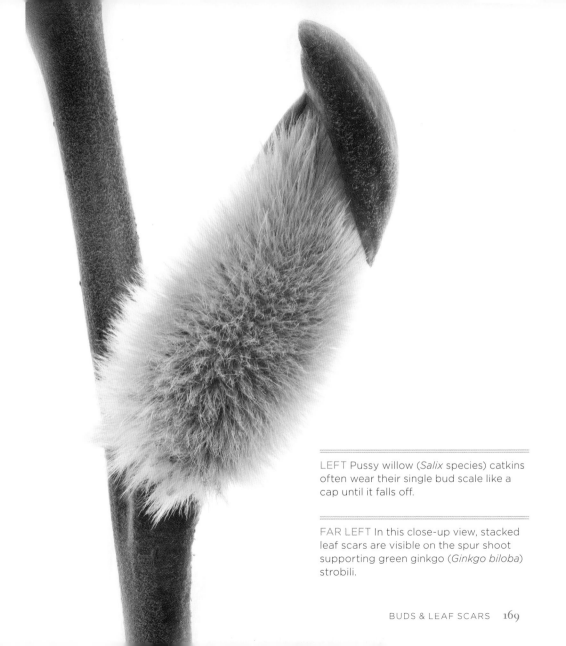

LEFT Pussy willow (*Salix* species) catkins often wear their single bud scale like a cap until it falls off.

FAR LEFT In this close-up view, stacked leaf scars are visible on the spur shoot supporting green ginkgo (*Ginkgo biloba*) strobili.

BARK & TWIGS

BARK IS, AS MOST PEOPLE KNOW, PROTECTIVE covering for living parts of the tree beneath. Some of its less-known functions include protecting the tree from parasites, preventing water loss, and insulating the tree from heat, thereby reducing the tree's vulnerability to fire. On young trees, bark is usually smooth (on the sassafras, it stays smooth and green for a long time). A few species, like beech and ironwood, have bark that stays smooth throughout the tree's life, but on most trees, bark roughens up as the tree ages.

As the interior of the tree grows, the tree's outer bark begins to crack open or peel off in a

Bark sloughed off by American sycamore (*Platanus occidentalis*) often gathers under the trees and along rivers and streams, where it dries and curls into phantasmagorical shapes.

way that is characteristic of the species. Those with exfoliating bark (the peelers) include river birch, yellow birch, sycamore, crape myrtle, red cedar, northern white cedar, and shagbark hickory. Many more species have bark that cracks or divides in characteristic ways to accommodate the expanding trunk. How it cracks and divides—into what patterns and to what extent—can be a clue not only to the tree's identify but to the age of the tree. Things to look for include the shape and orientation of the bark's furrows or fissures. Do they run up and down the trunk, diagonally across the trunk, or do they crisscross? Are they short or long, close together or far apart? Do they break the surface of the bark up into longitudinal ridges, irregular squares, or rectangles? The ridges between bark furrows also have characteristic shapes and textures. They can be smooth or scaly, pointed or flat-topped, tall or short. As tupelo ages, for example, its bark gets thicker and thicker, and the furrows in the bark of a really old tupelo can be two and a half inches deep—"so deep you could plant corn in them," a friend of mine once observed of a particularly ancient specimen.

The thick bark of an old black locust (*Robinia pseudoacacia*) has deep furrows and interlacing ridges.

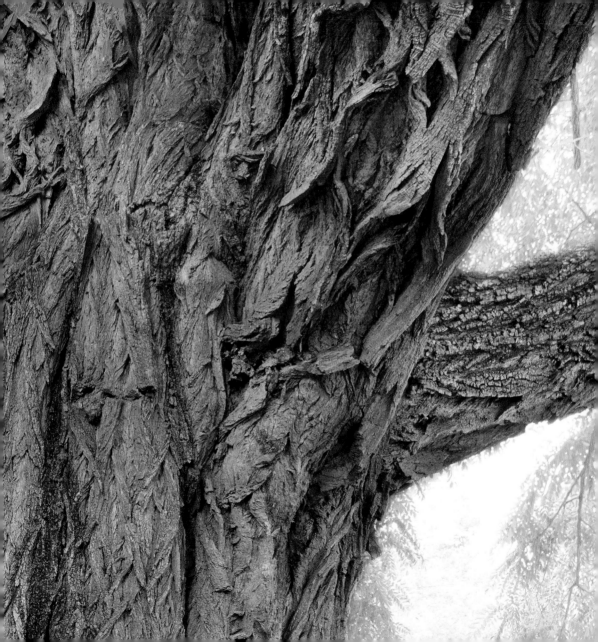

It is easy to appreciate a tree's bark. What's harder is describing what you see. I realized this when I tried to describe, for my grandchildren, bark on the lower trunk of a white oak we were passing. I referred to it as "alligatored" (I thought the alligator part would get their attention), but then it occurred to me that, having seen no alligators and probably no products made of alligator hide either, I was being less than helpful. "Plate-like," a term often applied to pine bark, can be equally unhelpful if it conjures images of dinner plates rather than tectonic plates. "Broad ridges of irregularly rectangular purple-tinged plates" is a good description of white pine bark I found on the Internet, but I'm not sure anyone who doesn't already know pine bark could pick a pine out of a lineup using it.

We probably need an entirely new language, with contemporary references, to describe bark and other tree traits to a new generation of naturalists, but even more important is just getting people outside to witness these phenomena. Bark and characteristic twig features are particularly valuable for tree viewers to know in winter: not only do they help you identify trees after the leaves have fallen off, but they allow you to

To appreciate the bark and bulk of a massive white oak (*Quercus alba*), look up into its branches rather than straight at them.

continue relating to and learning about trees when the ground is frozen. Even if you discover you can't identify a particular tree by its bark, twig structure, or other winter feature alone, you can combine these clues with other features, like spring leaves that emerge later, to develop the gestalt that will someday make this tree unmistakable in all seasons.

Twig structure or pattern of branching is another tree trait to be alert to, especially in winter, when you don't have leaves to distract you. Like tree leaves, which can appear on tree twigs in an alternate, opposite, or whorled arrangement, the twigs themselves develop in an alternate, opposite, or whorled arrangement. A tree that has an opposite leaf arrangement will also have an opposite twig arrangement, a tree that has an alternate leaf arrangement will have an alternate twig arrangement, and a tree with a whorled leaf arrangement will have a whorled twig arrangement. While a few common tree species (dogwood, ash, maple, princess tree, horsechestnut, and buckeye) have opposite leaf and twig arrangements, the great majority of trees have leaves and twigs that alternate along the twig or branch, respectively.

The bark of (left to right) river birch (*Betula nigra*), persimmon (*Diospyros virginiana*), and eastern red cedar (*Juniperus virginiana*).

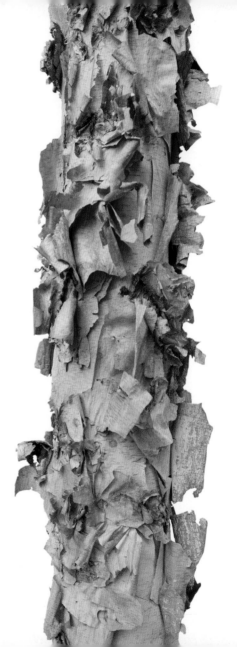

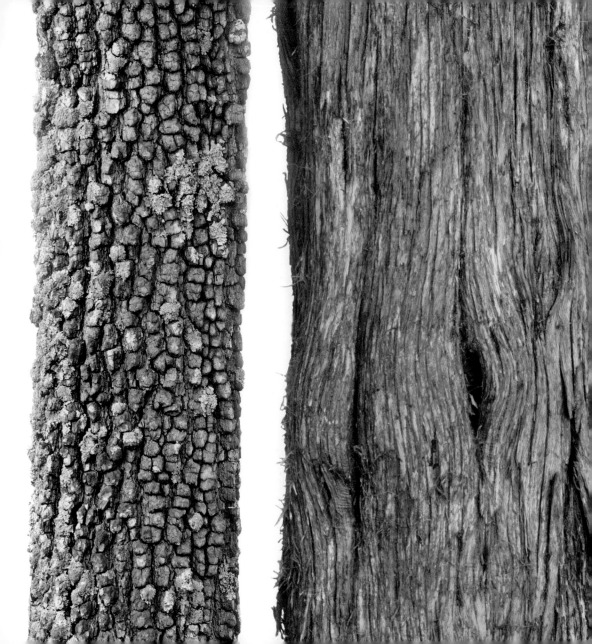

If you are a wildflower enthusiast, accustomed to successfully using leaf arrangement to help you identify wildflowers, you may find tree leaf and twig arrangements confounding. To my eye, these arrangements (partly because mechanical injury and animals destroy so many tree buds) are much less obvious on trees than they are on herbaceous plants, but occasionally you'll look up into a tree or down at a twig on the ground and see, say, the characteristic opposite twig arrangement on a red maple and think, aha, now I know you undressed.

Other twig characteristics to look for are their heft, texture, and color. The twigs of some tree species, like horsechestnut and hickory, are stout; others, like the twigs of beech and birch, are thin and graceful. The twigs of tree-of-heaven are so fat, it seems like a misnomer to call them twigs; the twigs of ironwood are so thin they seem thread-like. Some young twigs are roughed by lenticels (breathing pores), which can be raised or level with the bark, and some, like those of winged elm and sweetgum, have corky, wing-like appendages. Young red maple twigs are red, some willows yellow, boxelder green, and, although this moves us from sight into a different sensory category, you can recognize some tree species by the characteristic smell of their twigs. Abrade the twig bark of black birch for the fragrance of wintergreen, sassafras for root beer, wild black cherry for almond, and tree-of-heaven for peanut butter. ❖

Corky, winged bark characterizes young sweetgum (*Liquidambar styraciflua*) trunks and twigs.

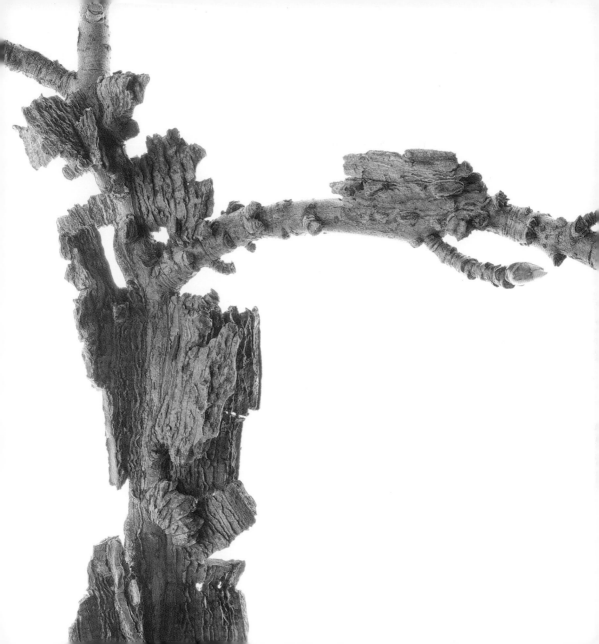

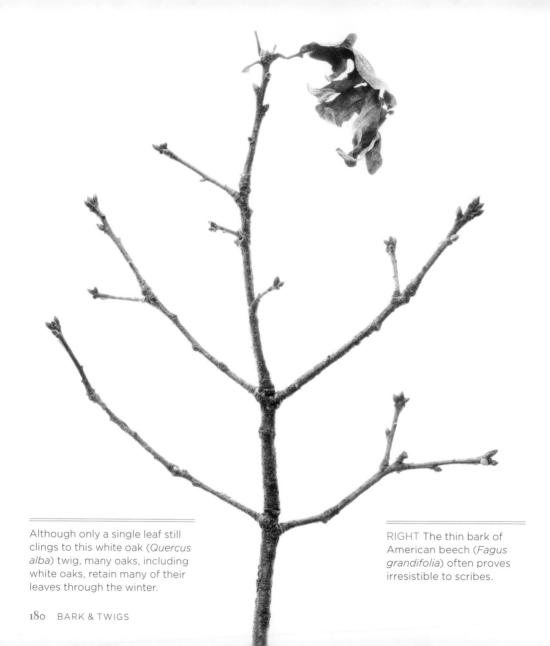

Although only a single leaf still clings to this white oak (*Quercus alba*) twig, many oaks, including white oaks, retain many of their leaves through the winter.

RIGHT The thin bark of American beech (*Fagus grandifolia*) often proves irresistible to scribes.

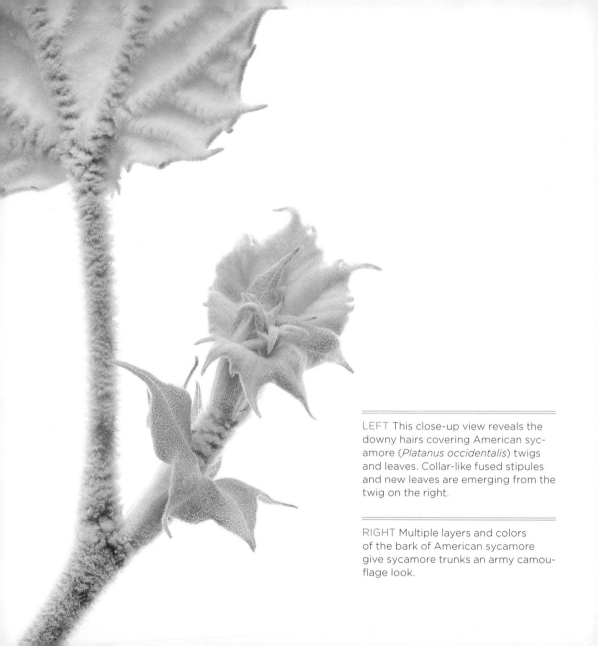

LEFT This close-up view reveals the downy hairs covering American sycamore (*Platanus occidentalis*) twigs and leaves. Collar-like fused stipules and new leaves are emerging from the twig on the right.

RIGHT Multiple layers and colors of the bark of American sycamore give sycamore trunks an army camouflage look.

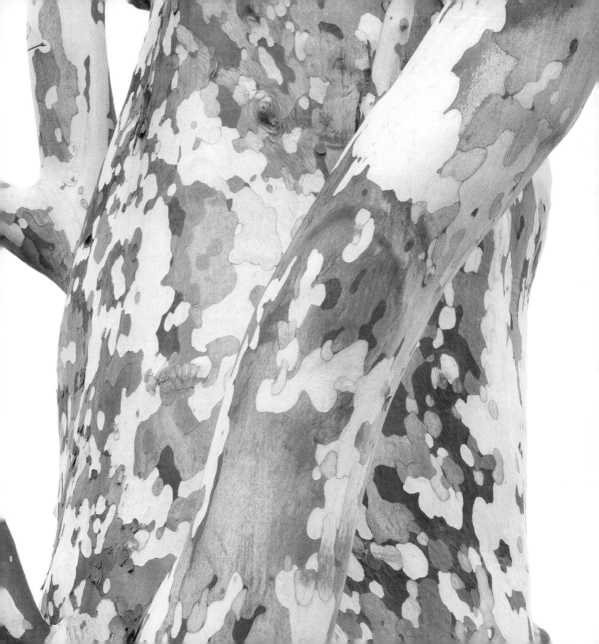

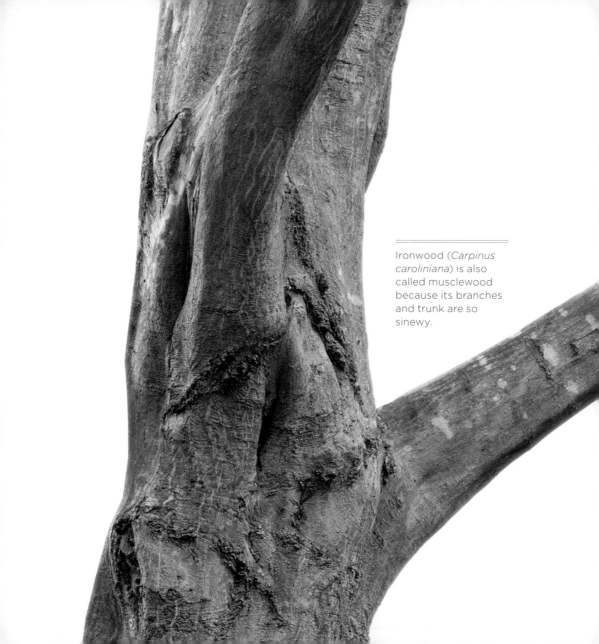

Ironwood (*Carpinus caroliniana*) is also called musclewood because its branches and trunk are so sinewy.

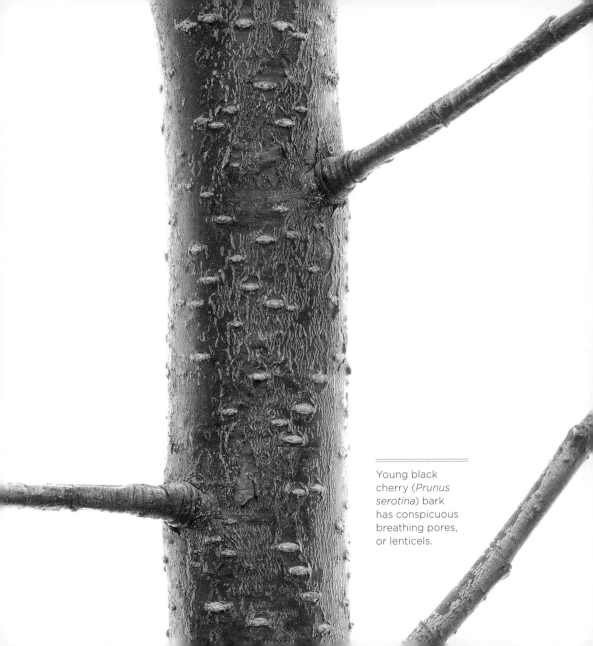

Young black cherry (*Prunus serotina*) bark has conspicuous breathing pores, or lenticels.

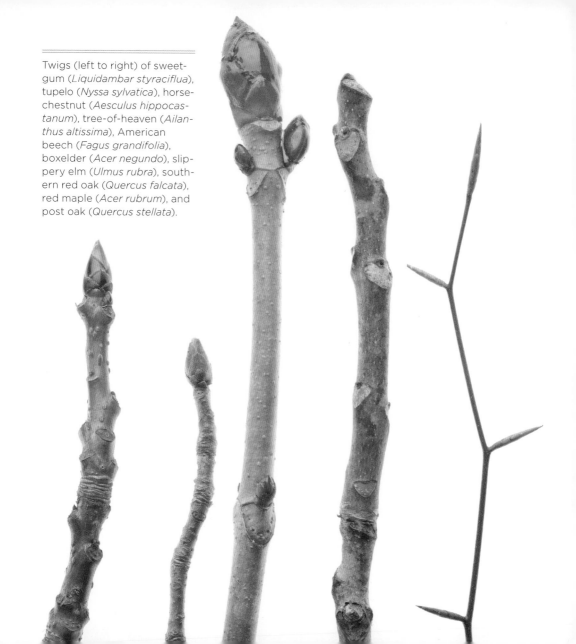

Twigs (left to right) of sweet-gum (*Liquidambar styraciflua*), tupelo (*Nyssa sylvatica*), horse-chestnut (*Aesculus hippocastanum*), tree-of-heaven (*Ailanthus altissima*), American beech (*Fagus grandifolia*), boxelder (*Acer negundo*), slippery elm (*Ulmus rubra*), southern red oak (*Quercus falcata*), red maple (*Acer rubrum*), and post oak (*Quercus stellata*).

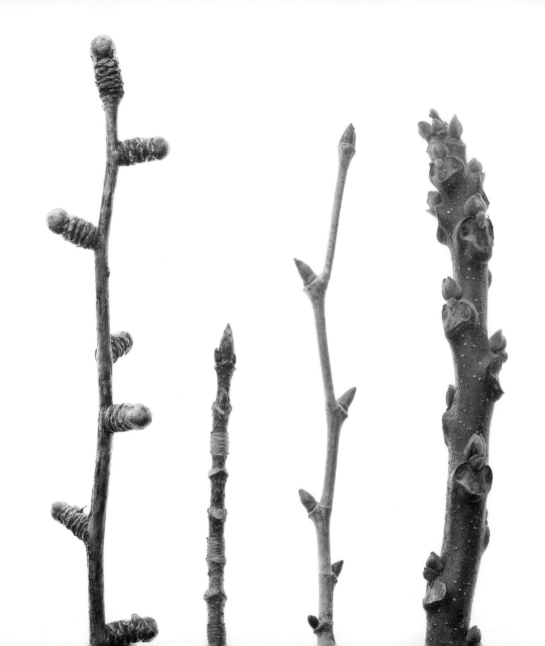

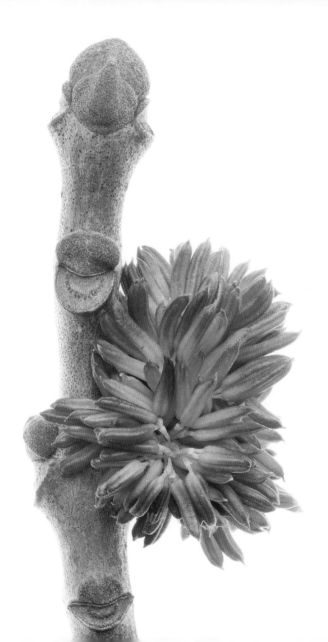

LEFT Tight clusters of immature male flowers bloom along this white ash (*Fraxinus americana*) twig.

FAR LEFT Twigs (left to right) of ginkgo (*Ginkgo biloba*), sugar maple (*Acer saccharum*), American sycamore (*Platanus occidentalis*) and black walnut (*Juglans nigra*).

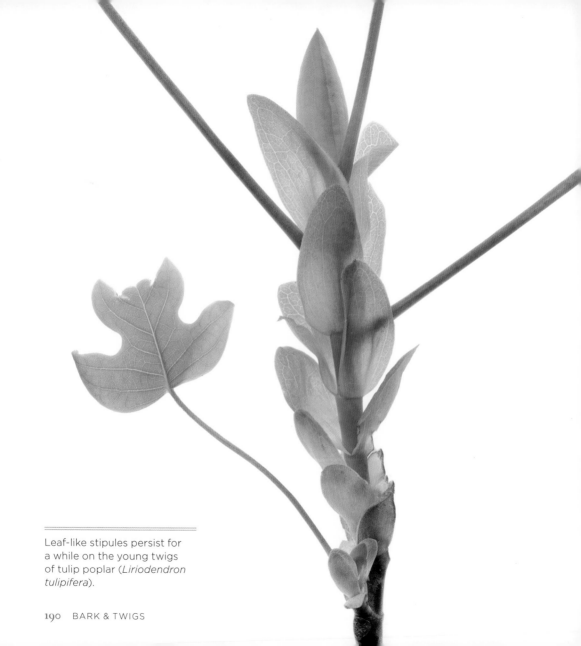

Leaf-like stipules persist for a while on the young twigs of tulip poplar (*Liriodendron tulipifera*).

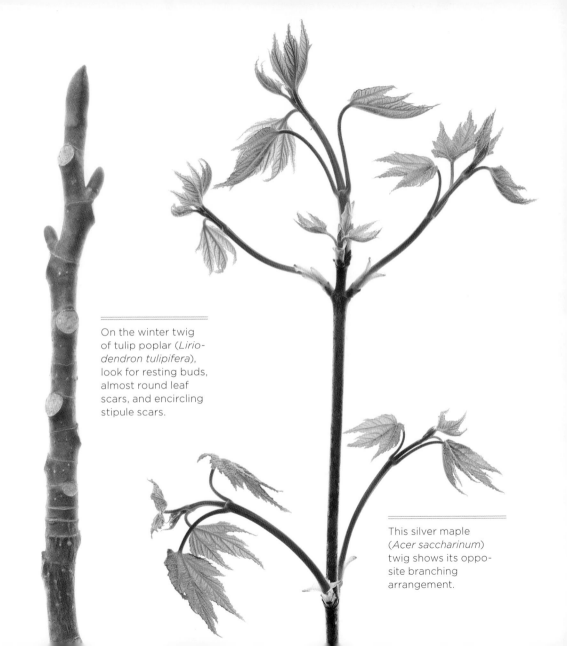

On the winter twig of tulip poplar (*Lirio-dendron tulipifera*), look for resting buds, almost round leaf scars, and encircling stipule scars.

This silver maple (*Acer saccharinum*) twig shows its opposite branching arrangement.

The twigs of red maple (*Acer rubrum*) are bedecked with clusters of red flowers in early spring. These are female.

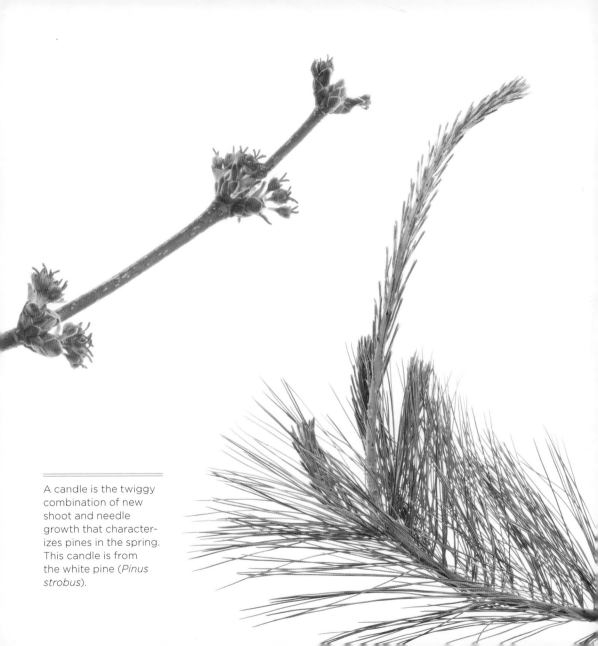

A candle is the twiggy combination of new shoot and needle growth that characterizes pines in the spring. This candle is from the white pine (*Pinus strobus*).

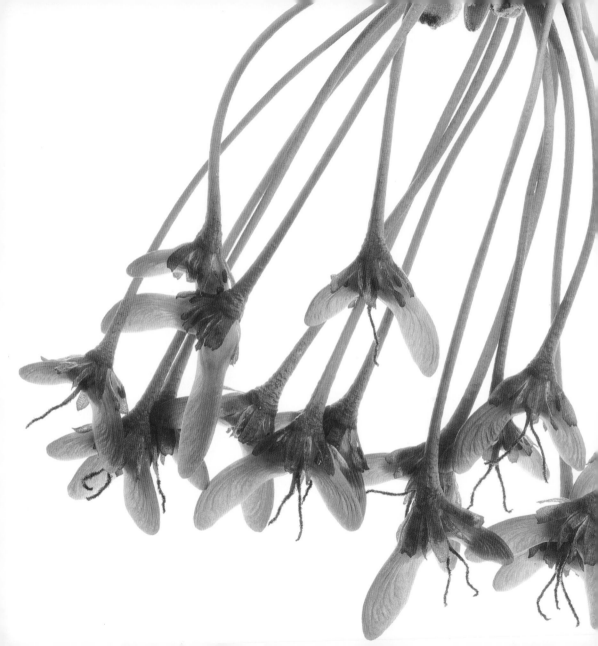

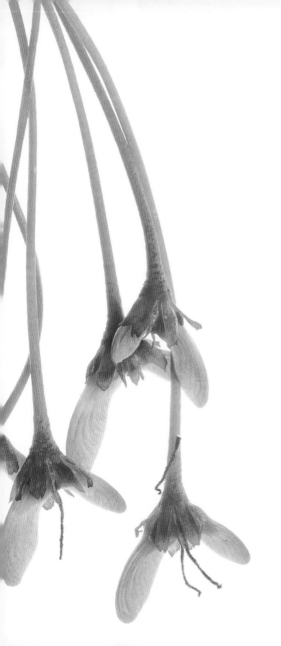

INDEX

Young red maple (*Acer rubrum*) fruits, or samaras, are developing on stalks that, earlier in the season, bore female flowers.